Images of America
Oceanside Fire Department

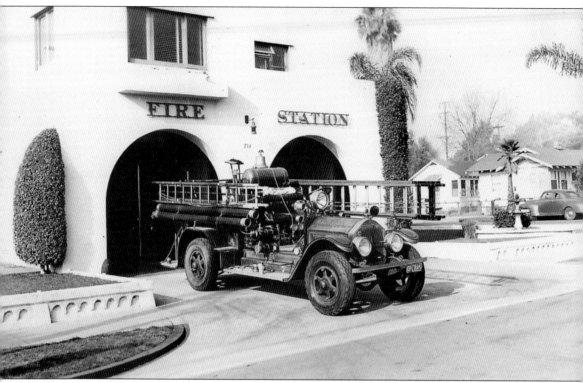

This 1923 American LaFrance was Oceanside's first mechanical fire apparatus. Here it is pictured in front of Oceanside Fire Station No. 1, which was built in 1929. It is listed in the National Register of Historic Places as one of the nation's oldest working firehouses. (Oceanside Fire Department.)

ON THE COVER: This photograph was taken in front of station No. 1 on 714 Third Street (now Pier View Way) in 1959. Sitting on the rigs are, from left to right, Dick Trotter, John Guest, and Jack Rosenquist. In the first row are, from left to right, Don Guest, Jim Brown, Harry Hickok, Bill Bond, Irwin Heald, Harry Morse, Lloyd Seal, Jim Hicks, Roger Carson, Jerry Graben, and Gene Waters. (Oceanside Fire Department.)

IMAGES of America
OCEANSIDE FIRE DEPARTMENT

Stu Sprung and Mark W. Finstuen
Oceanside Fire Department

Copyright © 2010 by Stu Sprung and Mark W. Finstuen, Oceanside Fire Department
ISBN 978-0-7385-8105-7

Published by Arcadia Publishing
Charleston SC, Chicago IL, Portsmouth NH, San Francisco CA

Printed in the United States of America

Library of Congress Control Number: 2010926980

For all general information contact Arcadia Publishing at:
Telephone 843-853-2070
Fax 843-853-0044
E-mail sales@arcadiapublishing.com
For customer service and orders:
Toll-Free 1-888-313-2665

Visit us on the Internet at www.arcadiapublishing.com

CAPT. KURT KREBBS, 1960–2006. This book is dedicated in the memory of OFD captain Kurt Krebbs, who died in the line of duty after a house fire on April 7, 2006. Kurt was an Oceanside resident who took pride in serving his community. We are donating 100 percent of the royalties from this book equally to the Oceanside Firefighters' Charity and Community Committee (www.oceansidefirefighters.net) and the Firehouse Brewing Company Foundation's Widows and Orphans Fund (www.firehousebrew.com).

Contents

Acknowledgments		6
Introduction		7
1.	Evolution of a Legacy	9
2.	Oceanside Fire Company 1, Established 1887	23
3.	Captain Seal, the Saint Malo Lumber Fire, and the Return of the White Whale	37
4.	Truck 5 and Substation 2	49
5.	The Cowboy Fire Chief	61
6.	The Sixties, U.S. Interstate 5, and Macaroni for Lunch	65
7.	San Diego County's First Johnny and Roy's . . . and Lime Green Rigs	73
8.	The Rodeo Years	91
9.	www.osidefire.com	107

ACKNOWLEDGMENTS

We would like to extend a special thanks to every firefighter of the Oceanside Fire Department, especially fire chief Darryl Hebert and Oceanside Firefighters' Association president Greg de Avila (OFD fire captain). Without their unquestioning early support, this project never would have seen the dim light of any firehouse bookshelf.

Also this book would not be possible without the contributions of many of the Oceanside firefighters, past and present, who have taken the time throughout the years to collect photographs, newspaper clippings, and stories of our unique history. OFD captain Lloyd Seal (retired) was instrumental in recounting his tragedy at the Saint Malo Lumber Fire. Division chief Ken Matsumoto, who has archived most of our photographic history, was simply priceless. Special thanks to Capts. Frank Imbilli (retired) and Bill Betz (retired) and engineer John Wayne (retired) for also preserving, researching, and documenting much of the OFD's history. We would also like to express gratitude to battalion chiefs Bob Cotton and Richard Thompson (retired) for assistance with identifying personnel and sharing their stories from the early years. And we would also like to thank firefighter/paramedic Mike Farnham for taking a genuine interest in this project and going to every fire station, on every shift, and making sure that every current OFD firefighter is represented in this book.

Special thanks also to Delores Davis Sloan and the many other OFD family members that have been gracious enough to allow us access to their albums and to Julie Faumuina for her contributions as well.

Finally we would like to acknowledge and thank Kristi Hawthorne and Janice Ulmer for their tireless efforts at the Oceanside Historical Society (www.oceansidehistoricalsociety.org). They were able to provide invaluable photographs and documents to add to our collection. All images used in this book come from the Oceanside Fire Department Archives unless otherwise noted.

INTRODUCTION

"Oceanside is exceptionally well equipped for fire protection, has well-trained firefighters, and has every reason to be proud of its fire department," according to Walter Johnson, Oceanside fire chief, May 3, 1933.

The history of Oceanside dates back to 1769, when it was first visited by European explorers. At the time, the territory was still under Spanish and Mexican rule. In 1798, Spanish missionaries settled and created the Mission San Luis Rey, the most expansive of what would become known as the Spanish Mission Church Complex. This network of 21 missions would stretch from San Diego to San Francisco and would be connected by a "trail" that would become famously known as the El Camino Real.

After California was annexed by the United States in 1848, it would take another 40 years for settlers to incorporate the city of Oceanside. Part of that incorporation included the establishment of an official fire company (in 1887, an informal volunteer Oceanside fire company was created), which essentially incorporated a hose cart, some fire hydrants, a fire bell tower, and some volunteers.

It was during this time that Oceanside experienced a rare stretch of time with no significant fires, which in turn resulted in the community's lack of emphasis on fire services. That was until June 13, 1896, when passengers on a southbound train noticed flames blowing out of the roof of the majestic Pacific Hotel, a popular oceanfront resort that had only been built eight years earlier. Due to the lack of adequate fire protection, it burned to the ground and, according to the June 14, 1896, *Oceanside Blade-Tribune*, "was destroyed as it was built, in a blaze of glory."

At the very next town hall meeting, a serious commitment to fire protection was made. A fire board was appointed and more hose carts were added, marking the first modernization of the Oceanside Fire Department. These carts were subsequently spread around the city in various stables, garages, and motels. Then in the mid-1920s, Oceanside's first motorized apparatus was purchased, a 1923 American LaFrance fire engine with a 40-horsepower engine and a 400-GPM pump. It cost $8,500 and was stored at the Oceanside Garage on Hill Street, which was the only building in town able to house such a thing and was the private business of fire chief Ernest White.

In 1929, the first fire/police station was built, with much effort coming from Oceanside's most legendary fire chief, Walter Johnson. Eighteen volunteers served Oceanside's 4,200 citizens. That structure is still the present-day location of Oceanside Fire Station No. 1, which just happens to be situated on the former homestead of Andrew Jackson Myers, the founder of Oceanside.

In 1942, the U.S. government established Camp Pendleton for the U.S. Marine Corps, which became home to the legendary 1st Marine Division. (Since then, many of Oceanside's firefighters and family members served there and have served in every major conflict since its inception, including World War II, Korea, Vietnam, and the Gulf War.) Being the nation's busiest military base, Camp Pendleton caused Oceanside's population to swell, which until recently had made the

Oceanside Fire Department the second largest and busiest fire department in San Diego County (next to the city of San Diego).

A growing population led to larger fires, one of which was the deadly Saint Malo Lumber Yard on March 11, 1961. Due to the intense, 100-foot flames, a downed power line temporarily disabled fire chief J. Billings. While he was able to free himself, Capt. Lloyd Seal became ensnarled and incapacitated. A local bystander attempted to free him and became electrocuted in the process and died. Captain Seal survived but suffered the loss of both legs.

While a department disaster was averted during that event, it would be 45 years, almost to the month, until Oceanside Fire Department would experience its first line-of-duty death. Fire captain Kurt Krebbs, following a difficult and prolonged house fire, would collapse and die from exposure to the fire.

A unique feature of the Oceanside Fire Department is that in 1975 it became the first fire department to train firefighters to provide paramedic service in San Diego County. Since then, OFD has gone on to lead the county with many innovative ways to deliver paramedic services.

Along with the mission and Camp Pendleton, Oceanside has been blessed with some of the best coastline in California, making it a popular tourist and surf destination. The Oceanside Pier, first built in 1888 and a stone's throw from the beach house used in the movie *Top Gun*, has been a landmark that is so popular it has been rebuilt six times. The fire department has trained and responded many times to the unique emergencies that result from such a structure.

If a Franciscan monk from the late 1700s was to travel along the El Camino Real today, he would first pass fire station No. 3 before climbing a hill to look down on two structures that appear similar in design and size. Turning west, he would find himself at the front door of Oceanside Fire Station No. 7, built in 2008. Oceanside's newest permanent fire station (there are eight total, with the last being in a temporary location) not only boasts being one of the largest and most modern fire stations in the world, it represents the importance of the Oceanside Fire Department's heritage and history, even in these modern times.

The fire department has been entwined with the history of Oceanside . . . actively participating and protecting it while the city grew from a simple homestead to a place of over 180,000 residents. Along the way, its firefighters have advanced from brave volunteers battling blazes with the equivalent of a salad bowl on their heads to modern professional firefighters with some of the best training and equipment available.

Although today's firefighting force bears almost no resemblance to the original one, its legacy is still intact, and it is hoped to carry on for at least 120 more years.

One
EVOLUTION OF A LEGACY

Oceanside Fire Company No. 1 was first established in 1887 by the city's founding fathers and citizens. At the time, the city of Oceanside was nothing more than a western outpost occupied mostly by settlers. With no experience and very few surrounding resources to draw upon, those settlers pioneered what has evolved into one of the most progressive and community-active fire departments in the United States.

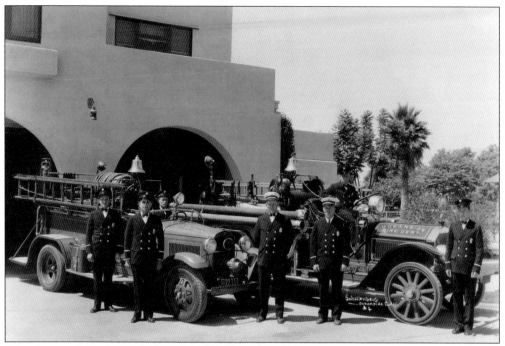

The first modern era in the history of the OFD started in 1929 with the building of the city's first fire station, which was located at what was then 714 Third Street. Pictured above are, from left to right, R. J. Bullard, H. B. Davis, John Todd, fire chief Walter Johnson, assistant chief Lee Jennings, Gus Millam, and Ernest Taylor. Eighty years later, that station still serves as Oceanside Fire Station No. 1 on 714 Pier View Way. Pictured below are, from left to right, firefighter paramedics (FF/PM) Felix Urrutia, Robert Castillo, Dan Karrer, Steven Choi, Capt. Andy Stotts, engineer Tony Chapman, Capt. Greg deAvila, Ryan Robinson, Rocky Rehberg, Jessamyn Specht, Mike Farnham, and Geoff Merzanis.

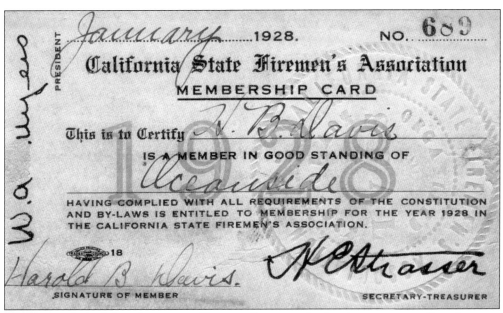

The Oceanside firefighters have a proud history of being involved in the community. Over the years, they have placed priority on the safety of Oceanside residents through their advocacy of adequate fire services. The California State Firefighters' Association (CSFA) was the first organization that allowed fire departments to unify with the goal of improving fire services throughout California. In 1923, the Oceanside Fire Department was the second department in the state to enroll with 100-percent membership. The CSFA is still the largest fire-service organization in California with 24,000 members. (H. B. Davis family.)

On September 17, 1931, firefighter Harold Davis holds on to the face valve for a new medical device called an "inhalator." This device was designed to provide respiratory assistance to individuals suffering from shortness of breath or cardiac arrest. Though an organized nationwide Emergency Medical Service system was still at least 30 years from being established, the OFD was one of the first to provide care with the bulky lifesaving devices to Oceanside's citizens. (H. B. Davis family.)

In 1929, Oceanside promoted Walter Johnson (center) as the city's first paid fire chief. With his signature cowboy hat, he became a symbol of progress by escorting the OFD out of the Wild West and into the 1950s. He is flanked (from left to right) by John Guest, Dick Trotter, Everett Stephens, and Rollin Calhoun. Pictured below, modern-day fire chief Darryl Hebert (second from left) stands with the OFD Fire Academy cadre.

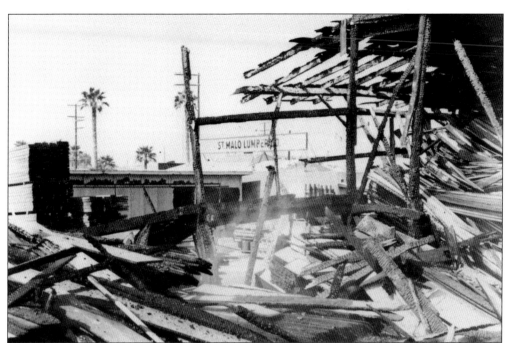

The evolution of the OFD saw some of the largest and most tragic fires in the city's history. At the Saint Malo Lumber Yard Fire (above), Capt. Lloyd Seal lost both of his legs and a good-samaritan bystander was killed trying to pull him from an electrified fence. In 1987, the Ice House Fire (right) was also one of the most interesting, as it burned for hours without being affected by thousands of gallons of water that were being poured into it. It turned out that the walls of the building were filled with sawdust as insulation, which gave firefighters the impression that no amount of water would ever extinguish the fire. (Above, Faumuina family.)

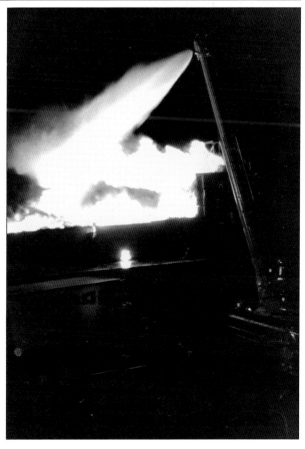

The 1960s and 1970s brought a new era, which consisted of fire chief Jack Rosenquist (above) and, from left to right, firefighters Mike Monreal, Rich Adams, and Capt. Jim Denny (below). The OFD's first 100-foot aerial truck, a 1977 Van Pelt, (above) was also purchased. (Above, Oceanside Historical Society.)

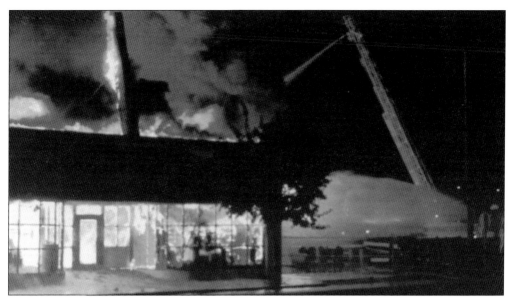

It did not take long for the new 100-foot aerial to be put to use, as shown here at the 1977 Lumber Yard Fire. The blaze burned so hot it blistered the paint and melted the truck's light bar and lenses. It was only one of two "low-rider" aerial trucks ever built. Another milestone to arrive to the Oceanside Fire Department in the 1970s was paramedics. In 1975, the OFD was the first fire department in San Diego County to integrate Advanced Life Support (ALS) services within the fire department and create a new rank, firefighter/paramedic, as pictured below.

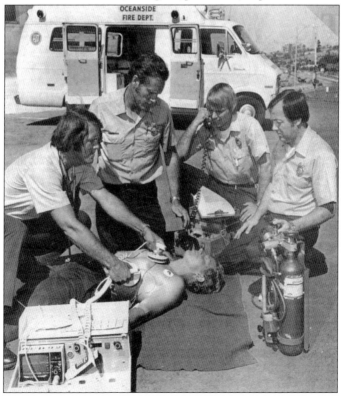

The transition from the 1980s to the 1990s was interesting not just for the OFD but for the city itself. The city gained notoriety for its location of the *Top Gun* House (above), and in 1992, the crew from OFD Medic Engine No. 21 was dispatched to Los Angeles to assist in firefighting and rescue efforts during the L.A. riots. Pictured below are, from left to right, FF/PM Rick Varey, Capt. Jerry Abshier, and FF/PMs Joe Urban and Ray Melendrez.

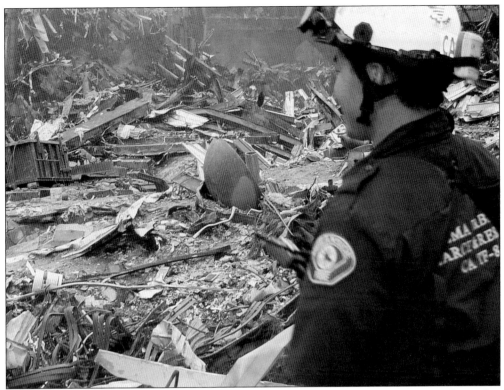

In the 2000s, firefighters from Oceanside were present at some of the greatest disasters and tragedies in American history. OFD division chief Ken Matsumoto (above) looks over Ground Zero as a member of San Diego County's Urban Search and Rescue Team. In October 2003, Capt. Mike Young and his crew from station No. 5 (below) battle the Cedar Fire, which became the largest wildfire in California's history.

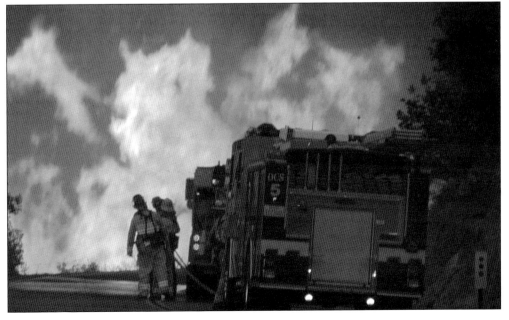

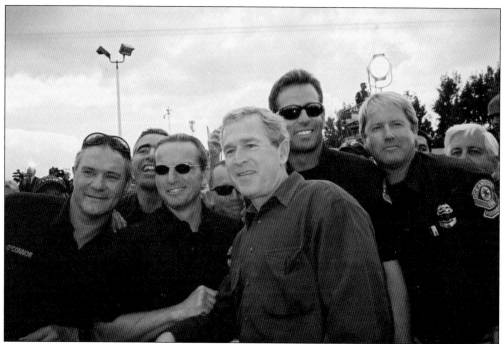

In 2006, the OFD suffered its first line of duty death when Capt. Kurt Krebbs (above right, wearing badge with black band) succumbed to exposure injuries following a difficult and prolonged structure fire. He is pictured here with President Bush during the 2003 Firestorm. Surfing is embedded in the OFD's culture. A memorial "paddle out" (below) was held for Kurt at the Oceanside Pier.

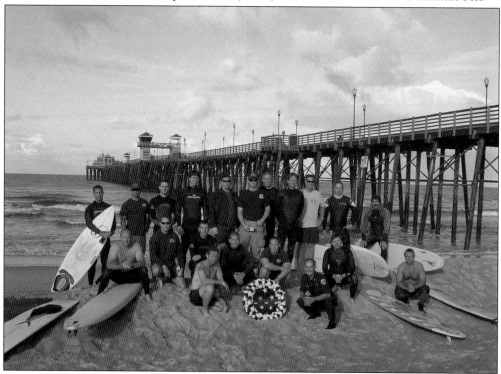

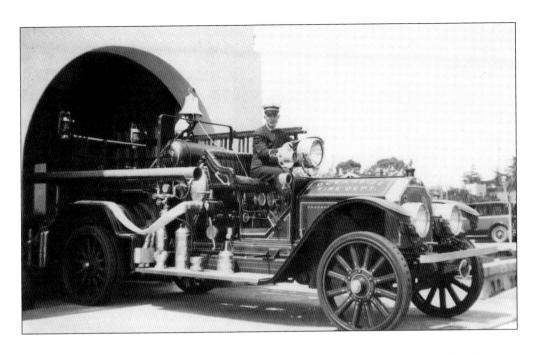

The first motorized fire apparatus for the OFD was a 1923 American La France (above), which pumped 400 gallons per minute. Eighty-five years later, the OFD has over 30 modern-day, state-of-the-art fire apparatus. Pictured below, this includes aerial trucks, engines, ambulances, and brush trucks.

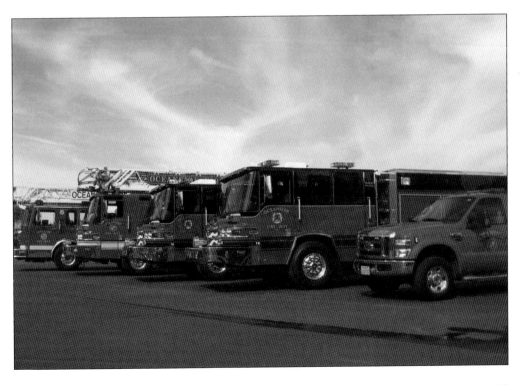

Battalion chief Everett Stephens (left) keeps a grip on his pipe as he wipes his eyes while progressing a hose line during a stubborn brush fire in the La Salina Canyon. Half a century later, brush fires continue to plague Oceanside. FF/PM Rocky Rehberg (below) battles an arson fire in the San Luis Rey riverbed. During a two-month period in 2007, OFD firefighters battled over 50 arson blazes in the riverbed.

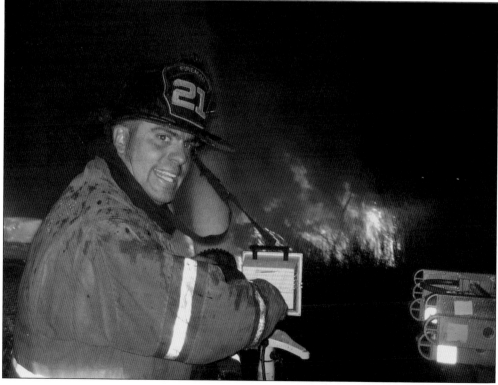

The OFD has always had a colorful cast of characters. Training officer Everett Stephens (right) is shown with a neighborhood child on Engine No. 2. Chief Stephens was somewhat of a contradiction as a training officer as he was a chronic pipe smoker. During training fires, while everybody else was low to the ground, he would stroll around upright in the dense smoke and heat and continue to puff away on his pipe. (Everett Stephens family.)

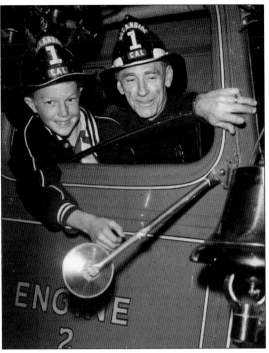

Known for never passing up a moustache contest or a good practical joke, FF/PM J. P. Neilson (foreground), pictured with engineer Justin Klopfenstein, is one of the modern firefighters keeping the tradition of OFD characters alive.

In 1887, Oceanside's firefighters fought blazes with buckets, dungarees, and cowboy boots. In 2009, the OFD maintains the legacy with that same spirit but with some of the best protective gear and equipment available. From left to right, FF/PM Jason Baker, engineer/PM Brian Myers, FF/PMs Lucifer Keener, Ian Shelton, an unidentified EMT, and Capt. Bill Kogerman at station No. 6 on North Santa Fe Avenue.

Two
OCEANSIDE FIRE COMPANY 1, ESTABLISHED 1887

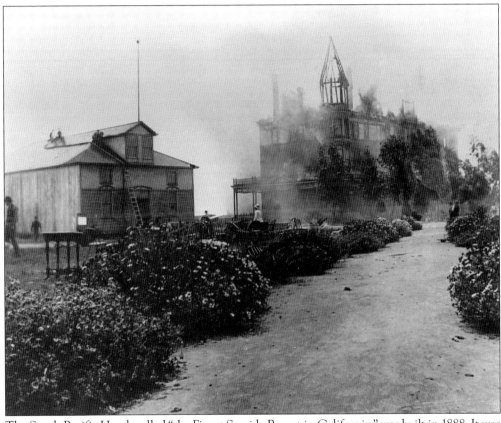

The South Pacific Hotel, called "the Finest Seaside Resort in California," was built in 1888. It was a majestic structure that, along with the railroad, was instrumental in putting Oceanside on the map. Only eight years later, it burned to the ground and was "destroyed as it was built, in a blaze of glory." With the organizational assistance of San Diego's fire chief, Oceanside's first volunteer fire brigade had been established in 1887, but its members did not have adequate equipment and training. And with the lack of fires, it was never a priority. Firefighters can be seen laddering the adjacent structure to protect flying embers from igniting it too. This would be the first significant fire in the history of Oceanside. (Oceanside Historical Society.)

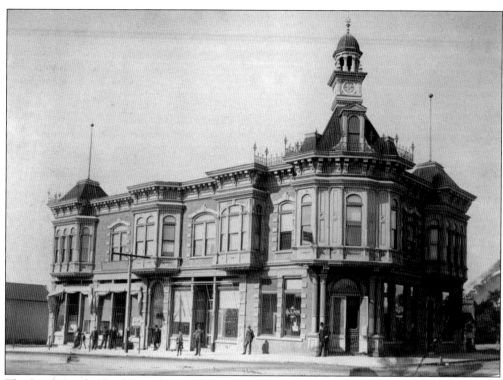

The South Pacific Hotel Fire, along with the construction of larger wood buildings such as the First National Bank on the corner of Second and Hill Streets, prompted public outcry and a resulting commitment by city leaders to invest more in the city's fire protection. This included the installation of "fire plugs," the purchase of two hand-pulled hose carts (like the one below), and the appointment of a fire board. Later, as automobiles became more prevalent, the city offered $3 to the first vehicle that pulled one of the carts to a fire. (Above, Oceanside Historical Society.)

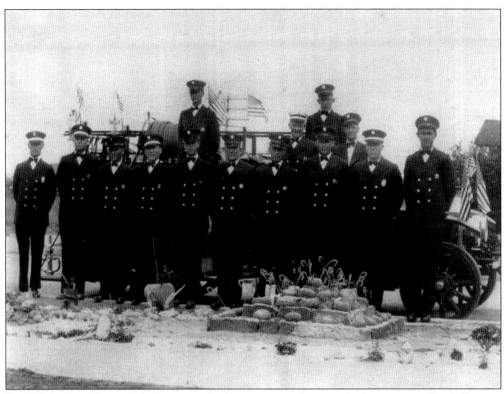

In 1888, before Oceanside's first motorized apparatus, volunteers had to run to a fire bell tower located at First and Freeman Streets. They would read the location of the fire off of a chalkboard and muscle the hose carts and wooden ladders to the fire. It would not be until 1925 that the OFD's first fire engine was purchased. It was housed at then–fire chief Ernest White's Oceanside Garage on Hill Street (below on the right), which also functioned as the police station. (Both, Oceanside Historical Society.)

For many years, it was a tradition for fire companies to record their activities in a log book. In this log entry from 1928, note the "Mexican Fire" on January 8, 1928, at 6:00 p.m. Eighteen of the 20 available personnel responded. At 50¢ for one volunteer per hour (the rate for actual firefighting duty since 1915), the extinguishment of this fire likely cost the city less than $20. The next year, fire station No. 1 was built by famed architect Irving Gill at 714 Third Street. It would also be shared with Oceanside Police Department as their headquarters. (Below, H. B. Davis family.)

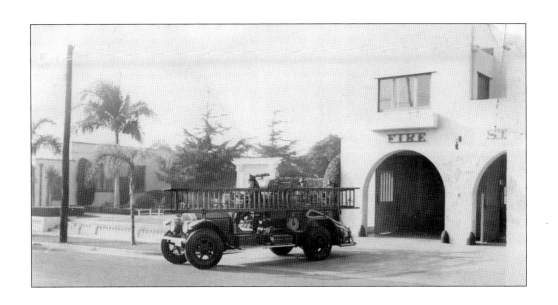

By the time station No. 1 was built in 1929 at the cost of $15,341, the population of Oceanside was approximately 4,200. Walter Johnson, a longtime volunteer assistant chief, was appointed as the city's first paid fire chief. The city also began to pay the new assistant chief, one captain, and compensated a roster of 18 volunteers per the call and training drill. (Below, Oceanside Historical Society.)

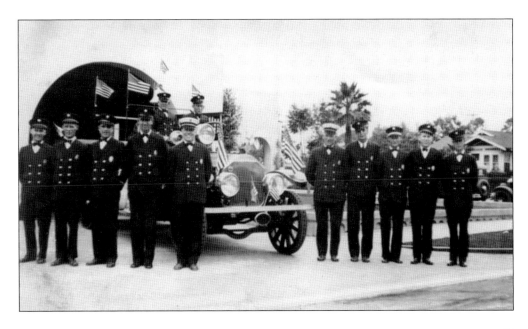

Harold B. Davis was a volunteer firefighter for 10 years. Here he is posing in his Class As on Labor Day 1931 outside station No. 1. (H. B. Davis family.)

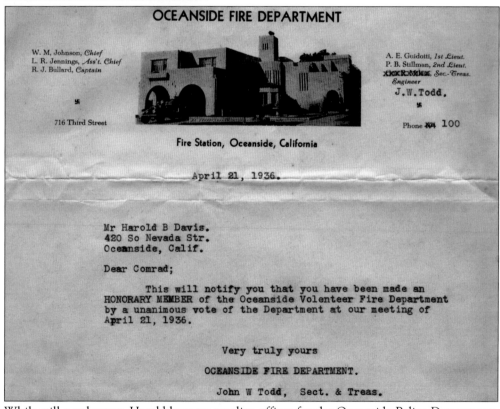

While still a volunteer, Harold became a police officer for the Oceanside Police Department. When he separated from the fire department, he was made an honorary member. He would serve as a police officer until retiring in 1955. (H. B. Davis family.)

In 1939, John W. Todd (center badge) became one of the first full-time, paid firefighters in Oceanside. He had already been a volunteer 1st lieutenant for at least 10 years. But soon after, in 1940, Todd died of complications from a ladder fall. Sadly he left behind his wife, Mary Todd, and five children. Then, only two years later, his son "Buddy" was killed in World War II when his U.S. Navy ship, the USS *Saratoga*, was sunk in the Battle of Guadalcanal. (Hence, Buddy Todd Park in Oceanside.) This letter (below) was written to the OFD by Mary (who by then worked for OPD) thanking them for helping her and her family get settled into their new home.

TELEPHONE 2166 305 NORTH NEVADA STREET

Oceanside Department of Police

William L. Coyle, Chief

POLICE RADIO IN REPLY REFER TO
K A D I FILE_____

OCEANSIDE, CALIFORNIA
1933 So. Ditmar St.,
April 21, 1944.

Oceanside Fire Department,
Oceanside, Calif.

 <u>Friends</u>;

 I wish to take this opportunity to thank the boys of the Fire Department for their in getting my family and I settled in our new home. As I've said before, it isn't the deed so much as the "thought" that prompted the deed.

 Again I thank you, dear Gang!

 Sincerely,

Mary B. Todd & Family

While today firefighter/paramedics staff fire department ambulances, back in 1929 ambulances not staffed by hospitals or morgues were staffed by police officers. Pictured above to the left, Buddy Divine poses with his shoulder holster in a typical Oceanside driveway. Pictured above to the right, Harold Davis (left) and Pat Stillman stand at the ready in front of station No. 1 in Oceanside's second fire engine, a 1932 Model-B Ford. Below is Engine No. 2, also parked in front of station No. 1. (Above left, Oceanside Historical Society; above right, H. B. Davis family.)

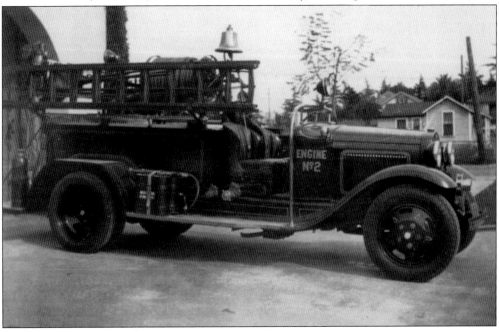

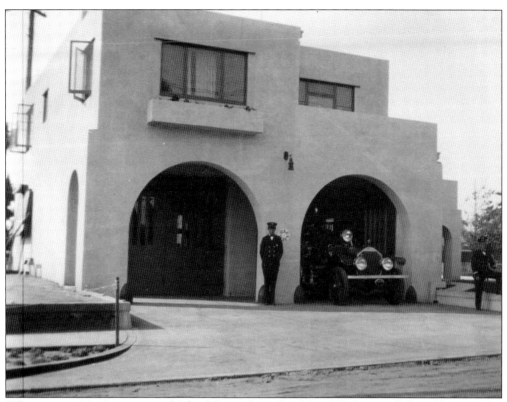

When station No. 1 was opened, Third Street (now Pier View Way) was still dirt. Also note the wooden, side-opening, manually-operated apparatus bay doors and the fire siren button between the two arches. (Oceanside Historical Society.)

This excerpt from the 1942 annual budget shows a cost of $585 for fire department personnel. Note that it is signed by John Landes, who now has a well-known city park named after him. (H. B. Davis family.)

Oceanside's police and fire departments would share the same station for almost 40 years, up until the police moved to their new station on Mission Avenue in 1968. Once the police were gone, the firemen wasted no time turning the jail into a dorm room. They sawed off all the bars to the cells and created what is still the firefighters bunk room today. Pictured below (from left to right), Harold B. Davis, Chief Walter Johnson, OPD officers Warren Paxton and Chas Goss, and firefighter Gus Millam stand on Nevada Street outside the police/fire station. (Both, H. B. Davis family.)

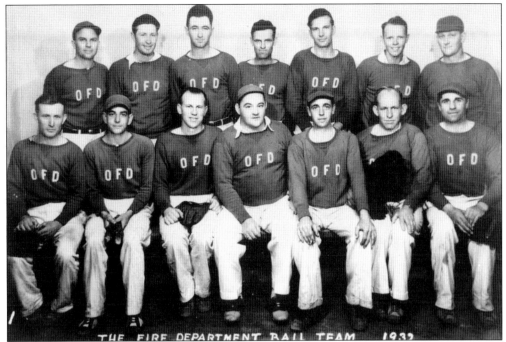

Two traditions synonymous with fire departments are baseball teams and firehouse dogs. Pictured here is the 1932 Oceanside Fire Company No. 1 baseball team with the firehouse dog, Blackie. The ball diamond where the team played was just west of fire station No. 1, where the old city hall and library sits. (H. B. Davis family.)

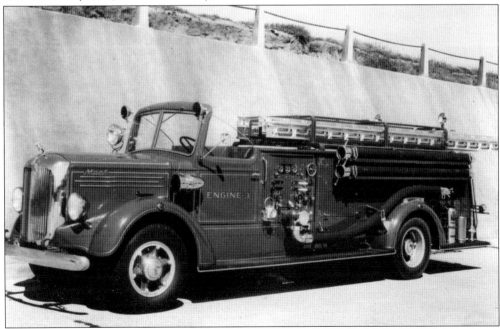

In 1939, the fire department purchased its first Mack fire engine, seen here parked on South Pacific Street in South Oceanside. This would be the first of many Mack fire engines purchased by the city.

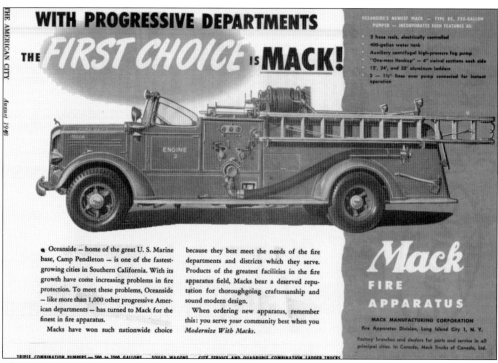

This advertisement, printed in a magazine called the *American City* in August 1948, highlights the purchase of the city's newest fire engine, a 1948 Type 85 Mack.

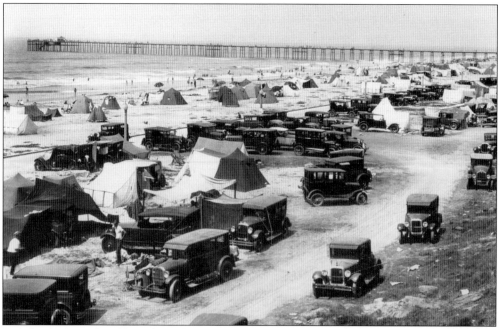

Fourth of July weekend has always brought the crowds to Oceanside's pristine beaches, creating unique challenges for the fire department. In the 1930s, the Great Depression also affected Oceanside. Tent City, shown here in the early 1930s, brought hundreds of families from afar to live and camp on the beach. (Oceanside Historical Society.)

This logbook entry from July 1949 shows some of the tasks carried out in preparation for the Independence Day festivities: polish truck No. 2 to put in the Fourth of July parade; go to the pier to place sacks for mortar tubes; go to the Big Top to wet down the sawdust; place fireworks in city yard office; go to the city fair to wet down grounds; and to pick up nozzle, hose, and buckets for fight arena.

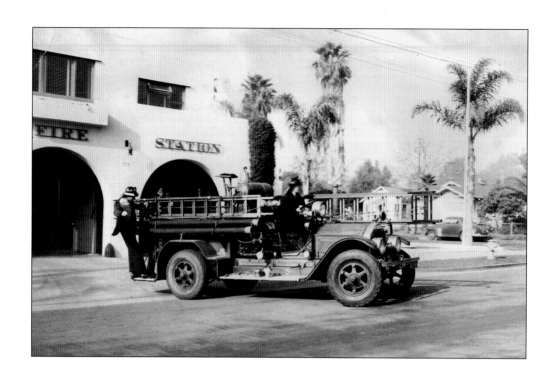

In 1948, after 23 years of service, the OFD's first fire engine, the 1923 American LaFrance, was captured in this sequence responding to its last alarm. Jack Williams is driving with Dick Trotter (right) and John Guest riding on the tailboard.

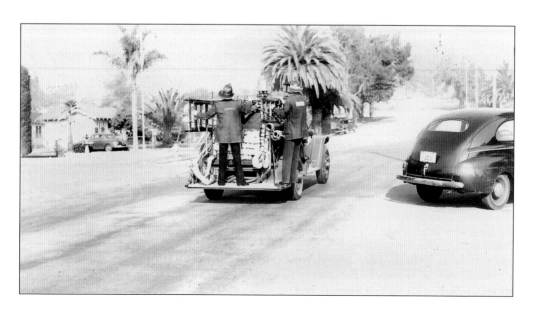

Three
Captain Seal, the Saint Malo Lumber Fire, and the Return of the White Whale

This is one of the most fascinating stories in the history of the Oceanside Fire Department. The White Whale is a 1952 Mack Model 95 L Series fire engine first purchased by the OFD around the same year. With a typical fire engine's service life of 12 years, it holds the distinction of being the most utilized piece of fire apparatus in the history of the Oceanside Fire Department. During its approximate 30 years of service, it saw action in some of the department's most significant fires to date. In 1981, it was sold and was taken by a collector to Oregon. This photograph was taken upon its return to Oceanside 24 years later.

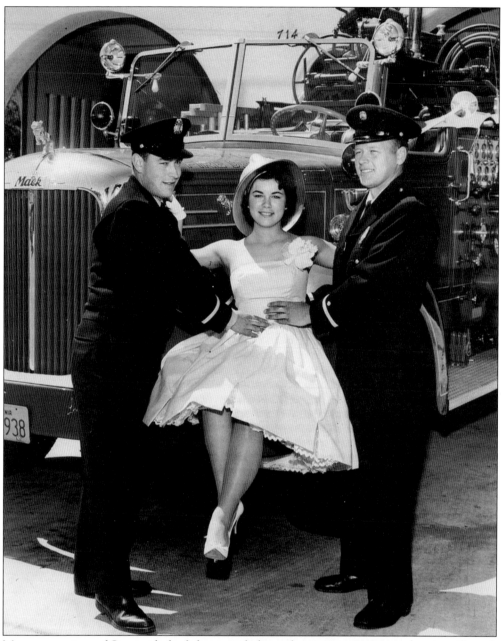

Many generations of Oceanside firefighters, including a few current ones, served on its tailboard. The White Whale actually spent most of its service life red, and the vehicle's official city designation was "F4," which signifies that it is the fourth apparatus assigned to the fire department since that labeling system was put in place. To give some perspective, the latest fire truck put into service is numbered F117. Pictured here, F4 is parked in front of fire station No. 1 with Diane "Flame" Killourhy, OFD's 1960 Miss Fire Prevention. She is flanked by Bob Yoeman (left) and Jack Rosenquist. (Rosenquist family.)

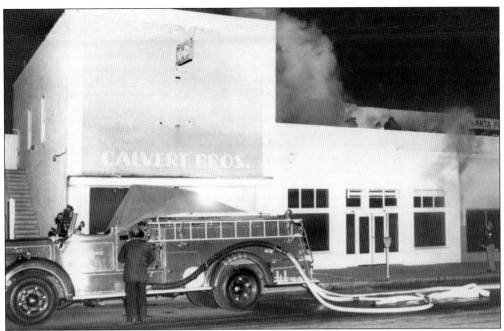

F4 is shown here during wintertime in the 1950s pumping a commercial fire on Hill Street as the firefighters make a hole in the roof with an axe. Notice the canvas tarp that has been fashioned as a tent to keep the cotton hose in the open hose bed from getting wet in the rain. Also the hydrant was connected directly to the hard suction, which could also be used to draft from a body of water in case there were no hydrants available. Below is Jennifer Brown, the daughter of firefighter Jim Brown, on F4's bumper in front of fire station No. 1. (Below, Brown family.)

On March 11, 1961, at 6:39 p.m., the Saint Malo Lumber Company on 1702 South Hill Street caught fire. It remains one of the largest recorded fires in the history of Oceanside. It was also one of the most tragic. (Faumuina family.)

It was an all-hands fire with fire apparatus from Oceanside, Carlsbad, and Camp Pendleton responding. By the time Capt. Lloyd Seal (left) and his crew aboard F4 arrived, a majority of the sheds in the vast lumberyard were already engulfed in 100-foot flames. Their task was further complicated by power lines being impinged by the flames and the rapidly increasing presence of hundreds of onlookers. As firefighters scrambled to fight the fire and keep onlookers back, tragedy struck. (Lloyd Seal.)

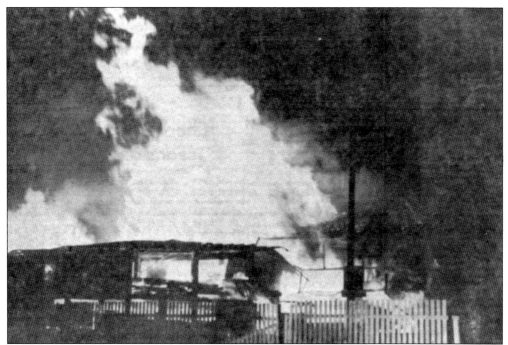

While F4 was busy pumping at capacity (pictured below), the high flames caused a 2,400-volt power line to drop, striking Chief Billings. While he was able to roll clear, Captain Seal was not as fortunate. Seal was instantly paralyzed (pictured below, in a cloud of smoke in the foreground) as the high voltage wire continued to electrocute him. A local resident, Fred Pimental, 24, who had run from his house four blocks away on South Clementine Street, joined onlookers who watched in horror as Lloyd continued to be electrocuted. Fred could not bear to watch the writhing figure suffer anymore, and ignoring shouts to stay back, he jumped into action. But as he did, he stepped on an electrified metal gate and reportedly "died instantly." (Below in light clothes to the left.) (Both, Faumuina family.)

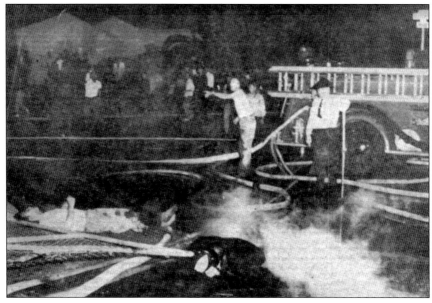

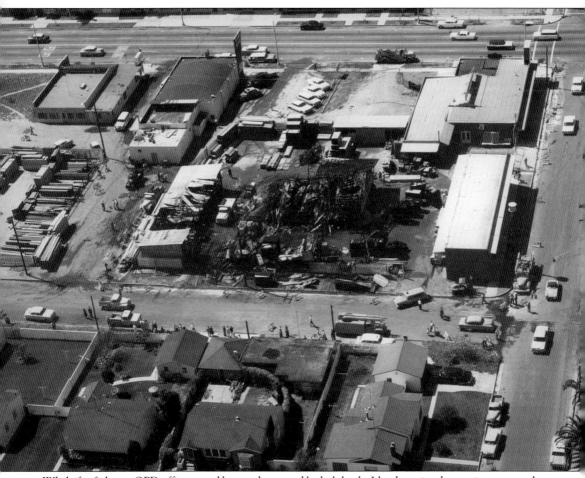

While firefighters, OPD officers, and bystanders stood by helplessly, Lloyd regained consciousness and, with the encouragement of fellow firefighters, was able to roll off of the live wire. It took approximately three hours for fire crews to get the blaze under control, which caused an estimated $75,000–$100,000 in damage. Pictured above, F4 is parked on the corner of Whaley and South Freeman Streets, only feet from where the tragedy occurred the night before. (Faumuina family.)

Dick Carboneau, the city editor for the *Blade-Tribune*, writes an emotional account of the incident from his perspective. (Faumuina family.)

EYEWITNESS REPORT
Fireman Crawls Away From Death

By DICK CARBONEAU
Blade-Tribune City Editor

I watched a man pull himself bodily from the brink of almost certain death Saturday night as a would-be rescuer lay dead only a few feet away.

Covering the St. Malo Lumber Company fire, I was inside the yard, watching the main shed go up in smoke, when a separate drama flashed to life not five yards away.

Having already been warned that power lines along Alvarado St. might drop at any moment, I knew what was happening when blue blasts of light contrasted with the red flames.

My head snapped around; I saw balls of light crackling along the wires.

The crowd drew back.

Presently I saw Fire Chief John Billing tumbling along the ground toward me. Confused shouts rang out:

"Get out of there!" "Stay back!"

"I'm all right; don't come over!" cried the chief as he

(Continued from Page 1)
scrambled to his feet.

It may have been seconds or minutes; I don't know. But suddenly I saw a dark, bulky object lying where the wire had dropped.

The object had a fireman's helmet. I realized in horror that another fireman had touched the deadly power line. It was Capt. Lloyd Seal.

Seal lay perfectly still. It seemed a long time that everyone stood there. Many people yelled not to touch him. This was good advice; he looked like he was dead.

Some people wanted to go to help Seal; I was one of them. But nobody did. Firemen themselves were warning everyone to stay back.

I felt yellow; common sense told me no one could help Seal without sacrificing his own life. I wanted to, but I couldn't.

One man tried, I learned moments later. Heedless of those who tried to restrain him, 24-year-old Fred Pimental ran toward Seal. He was out of my sight, around the corner of a building, when he apparently tripped and fell on the wire.

My feeling of cowardice was magnified as I saw Seal begin to move. He wasn't dead; he still could be helped, but I still was rooted to the spot.

Seal groaned. His voice cut into me, as it must have many others. His groan became barely intelligible.

"Pike pole — pike pole — pike pole — pike pole!" he cried with gathering strength.

I knew he was thinking; he wasn't crying to God for mercy; he was telling other firemen to bring him one of their long, wooden poles with a harpoon-like hook on the end. He thought it might be his link to life.

It seemed silly that no one brought the pike pole; I wished I had one.

The wire sizzled and sputtered under Seal's leg. It seemed to goad him to a superhuman effort. Sensing that he was gathering his strength, firefighters shouted his salvation to him.

"Roll, Lloyd; roll!"

Several voices urged him. Seal rolled off the wire; across the wire; across a fire hose; he kept rolling until he was almost in the middle of the street.

A dozen arms grasped Seal and dragged him to safety.

Presently he was taken to the Oceanside Hospital, where doctors said he had third degree burns on his left thigh and both legs from the knee down. He reportedly was paralyzed from the waist down.

Seal did for himself what Fred Pimental's apparent heedless dash of heroism failed to do.

Lloyd Seal also saved me — and probably many others—from eternally wondering, with sickening guilt, if we might not have been able to save him.

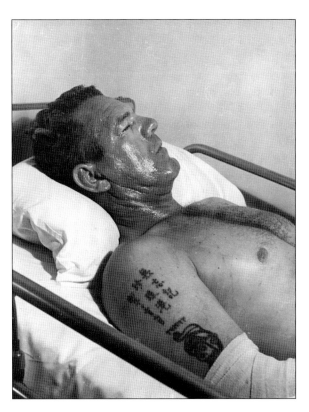

Captain Seal was transported to Oceanside Hospital on North Horne Street, where he was treated for third-degree burns to his left thigh and on both legs from the knees down. Unfortunately both of Lloyd's legs were amputated.

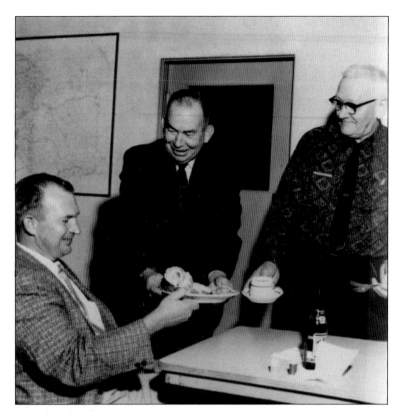

Ultimately Lloyd survived the near-death experience; however, the episode forced him to retire from the fire department. Here he is pictured at his retirement dinner with Oceanside fire chief Billings (left) and retired chief Walter Johnson. Lloyd currently resides in Union, Mississippi.

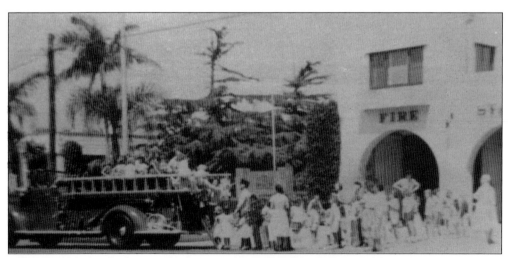

While Captain Seal's days on the rig were over, F4 still had 20 years of service to go. Pictured here, it is being used, back to business as usual, giving a ride to some local schoolchildren. And the rig would be involved in yet another significant event, the Laguna Fire in September 1970. While Capt. Joe Gregory, engineer Ted Wackerman, and firefighter Bob Cotton were protecting houses in a canyon, they were taken by surprise by some fast-moving flames. While the crew was spared, F4 was damaged and disabled beyond use.

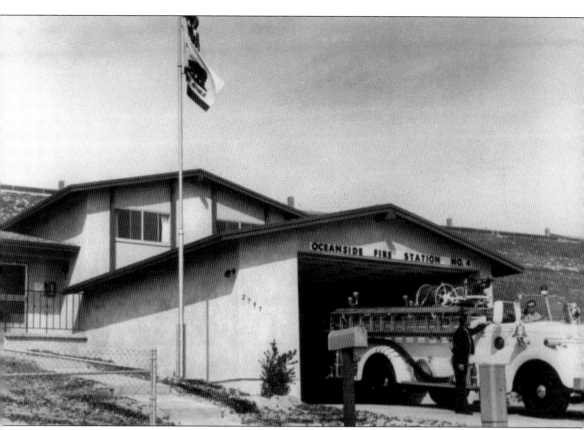

F4 was towed back to the city for repair. Around that time, there was a decree by the city manager that all Oceanside city vehicles be painted white. Although every other fire department engine was red, the firefighters dutifully painted theirs white. The fire chief protested loudly, and F4 is the only Oceanside fire engine ever painted white—hence, the White Whale. It is pictured above at the old fire station No. 4 on College Boulevard. F4 remained in service for the remainder of that decade and ran its last alarm in 1981. When it was auctioned off to a collector, the departure of the open-cab, 1000-GPM pumper marked the end of an era. It ended up in a barn in Oregon, where it was covered with an old tarp and driven only sporadically over the next 24 years. It seemed an inauspicious end for something that had seen so much action . . . until it came back home.

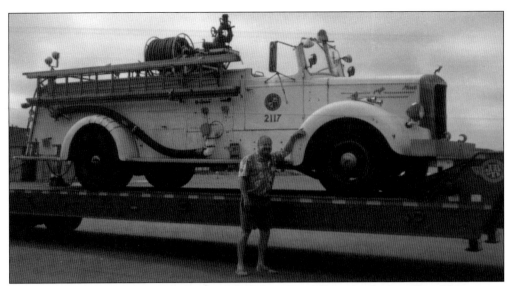

Rumor had it that the White Whale was up for bid on eBay. The owner had purchased F4 twenty-four years before and liked the idea of it returning to its original home, so he agreed to sell it to the Oceanside Firefighters Association for $6,000. In July 2005, Joe Brown, the son of a former 1950s-era Oceanside firefighter, drove a family business–owned flatbed up to Oregon to bring F4 home. Richard "Hatch" Baxter, a retired Oceanside fire engineer and F4 alumni (above), joined him for the trip. When it finally returned to Oceanside, the White Whale was covered in rust, and someone even pulled some chicken eggs from out of the fender wells. Pictured below, engineer Tom Schraeder steers F4, which has just been prepped for red paint.

Here F4 is returned to its former color, courtesy of Manheim Auto Auction in Oceanside. Many of the parts were powder coated courtesy of Racecar Dynamics of El Cajon and Bill Black from Fire Etc. Although F4 will no longer be fighting fires, it is sure to be a presence in parades, similar to the one below in the 1950s.

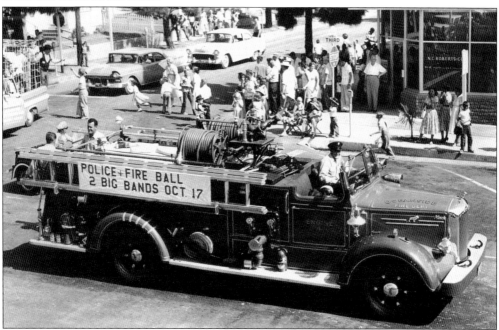

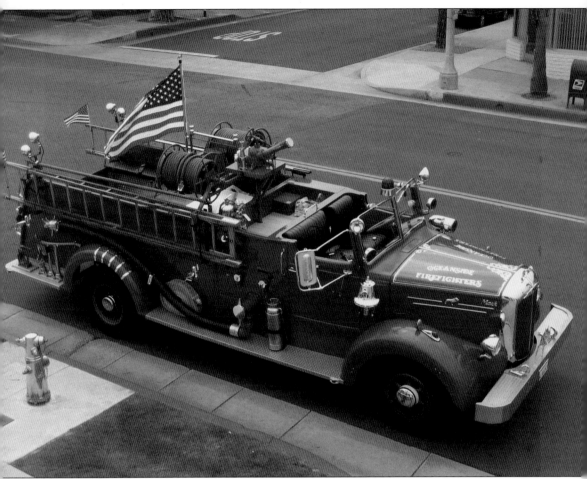

After thousands of hours volunteered by OFD members past and present, F4 is shown here restored to its original glory. The pump is strong and can still pump water for hours if needed, which is impressive for a restored fire engine. Here it is parked in front of fire station No. 1, only feet from where the parade photograph on the previous page was taken approximately 50 years earlier. This photograph was taken just before Oceanside's Fourth of July parade in 2010, just in time for spectators to appreciate the OFD's newest contribution to the history of the city. It was built to honor all those who have served on its tailboard and is dedicated to the memory of Richard "Hatch" Baxter, who was instrumental in bringing it back home but passed away in 2008 before he could see it restored.

Four

TRUCK 5 AND SUBSTATION 2

A 1950s-era utility Jeep, "Truck 5" (an OFD-fabricated aerial truck), the 1939 and 1952 Mack trucks, and the 3000-gallon water tender "Tank 1" are parked outside of station No. 1. Along with an increasing assortment of non-hand-pulled apparatus, the 1950s brought a new era to the OFD. Fire station No. 2 would open in South Oceanside, and the group as a whole would become more social with the creation of a fireman's ball.

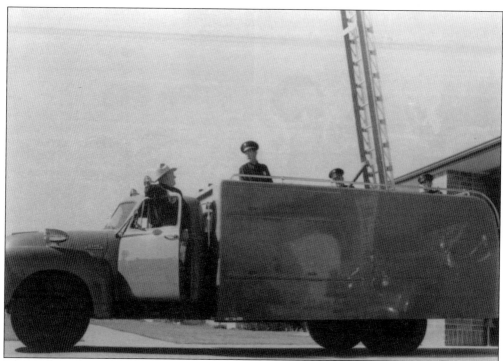

Chief Johnson seemed to appreciate firefighters who were mechanically innovative, which is an OFD tradition that carries on today. One of the first contraptions built by Oceanside firefighters was a spring-loaded aerial ladder on a swivel. This apparatus would be labeled "Truck 5," assuming this meant it was the fifth piece of equipment at the OFD. It was Oceanside's first ladder truck. Pictured below, firefighter Roger Carson cleans inside the wheel wells while firefighter Jim Brown's brother, Lonnie "Tiny" Brown, looks on. (Below, Carson family.)

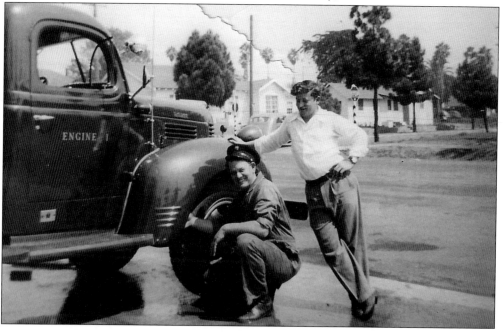

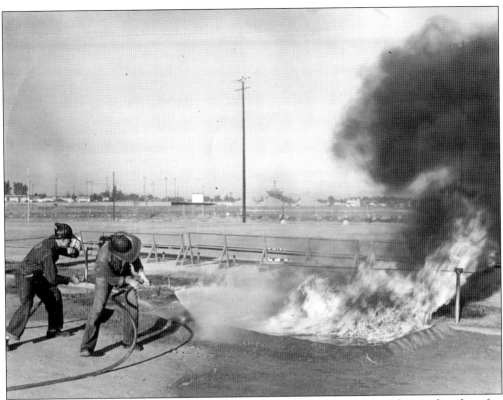

As both Oceanside and the fire department grew in size, emphasis began being placed on fire prevention. Pictured here, firefighters Jim Hicks (left) and Cliff Applegate provide a demonstration to students at Oceanside High School. Note how they flip their helmets around to shield their faces from the radiant heat. Pictured below from left to right, firefighters Dan Piercey, Harry "Smiley" Morse, and Capt. Everett Stephens relax outside station No. 1 after performing some apparatus maintenance.

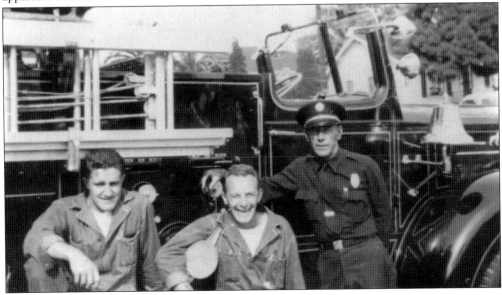

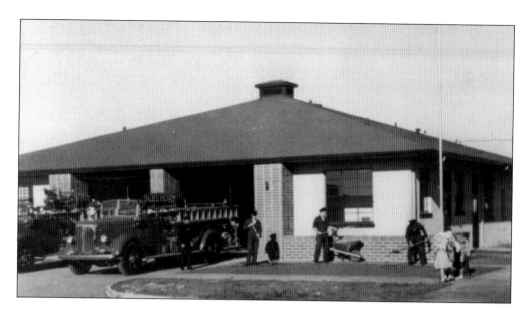

An article in the *Blade-Tribune* on October 22, 1951, described the proposed station No. 2, which would be located at 1740 South Ditmar Street, as a substation. It goes on to say, "the central fire station will be continued at its full fire fighting strength at its present location. Five additional firemen will be added to the department to staff the substation." On January 15, 1953, station No. 2 was opened at a cost of $37,879. Dignitaries from all over attended the grand opening, including several officers from Camp Pendleton representing Maj. Gen. Oliver "The Professor" Smith. The fire chief from Santa Ana also attended and commented, "If we can but save the life of one child, we have more than paid for such a building." (Below, Edith Swaim.)

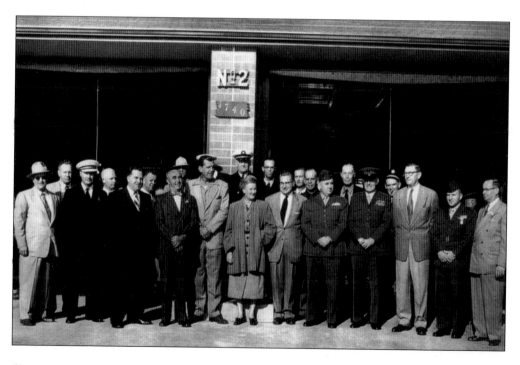

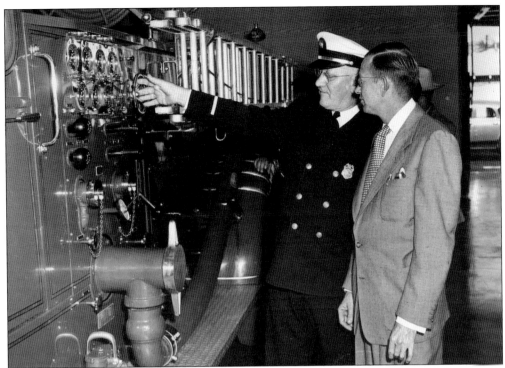

At the station No. 2 grand opening, Chief Johnson explains the complexities of a fire engine pump panel to Mayor Tom Wright. Pictured below, firefighter Roger Carson eases into his 24-hour shift with a cup of coffee and the morning paper. (Below, Carson family.)

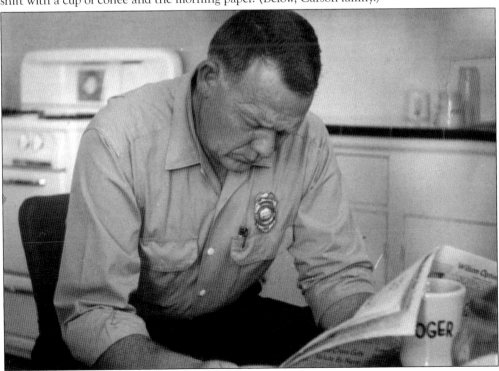

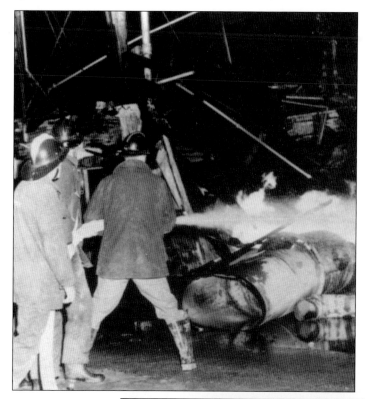

After a small fire back in 1924, the *Blade-Tribune* wrote, "this fire pointed out the fact that proper fire [protection] . . . was almost totally lacking." Ultimately this article prompted the purchase of the OFD's first fire engine. At the laundry fire on April 29, 1959, at 202 South Cleveland Street, Oceanside firefighters proved that was no longer the case. Pictured below, firefighters Smiley Morse (left) and Don Guest man a master stream.

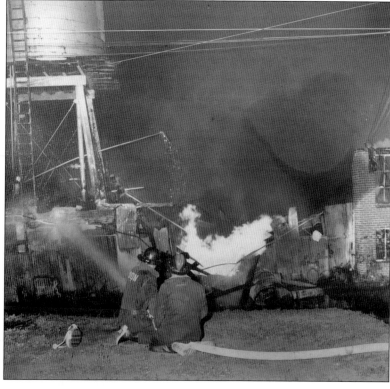

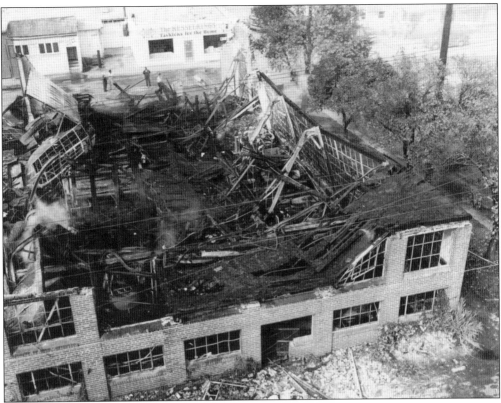

The large, two-story commercial facility was reported on fire by Margaret Bowen. Three OFD engines and Truck 5 responded, laying over 2,000 feet of hose. Along with 500,000 gallons of water and the help of Carlsbad and Camp Pendleton fire departments, the fire was extinguished without damage to any surrounding buildings. They even saved the trees immediately next to it!

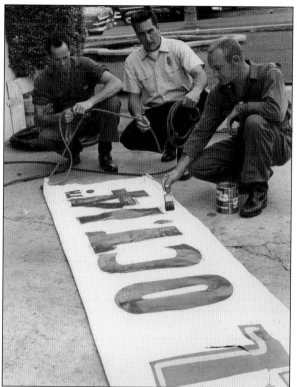

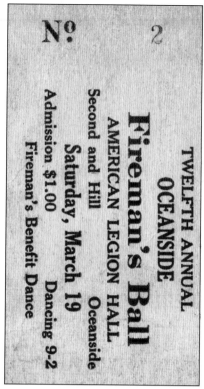

No. 2

TWELFTH ANNUAL
OCEANSIDE
Fireman's Ball
AMERICAN LEGION HALL
Second and Hill Oceanside
Saturday, March 19
Admission $1.00 Dancing 9-2
Fireman's Benefit Dance

In 1956, the OFD began holding firemen's balls. Most years, they involved the OPD as well, with proceeds benefiting the Police and Fire Benevolent Fund. Pictured above, firefighters Don Guest (left), Jim Oxley (center), and Smiley Morse paint a sign on the apron in front of station No. 1. Prior to the event, they would promote ticket sales throughout the city. Pictured to the left, OFD captain Gene Waters is driving as a horn-rimmed-shaded citizen receives a citation at axe-point from OPD officers Dick Bingham (left) and Hank Himmelspach.

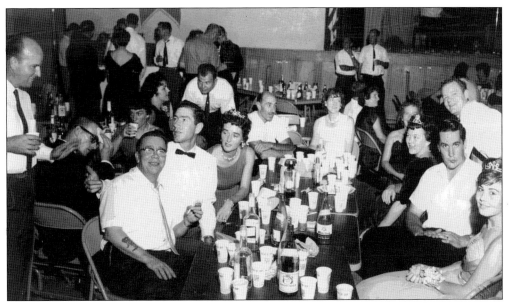

This is at the 1959 Police and Fire Ball at the Oceanside Community Center on The Strand, just north of the pier. Identified are Gene Waters (far left), Bill Bond (looking around), and Joe Curtis (far right, bending over smiling). Note the piano player taking requests up on the stage as the champagne and Dixie cups fill the tables. One year, entertainment included an OFD firefighter band called the Firehouse 5. Below are four OFD spouses at one of the many early formal events at station No. 1, which is home to the only brass pole in the city. That pole has allowed hundreds of Oceanside firefighters quick access to fire engines and ambulances thousands of times since 1930, helping them get to emergencies just a little quicker.

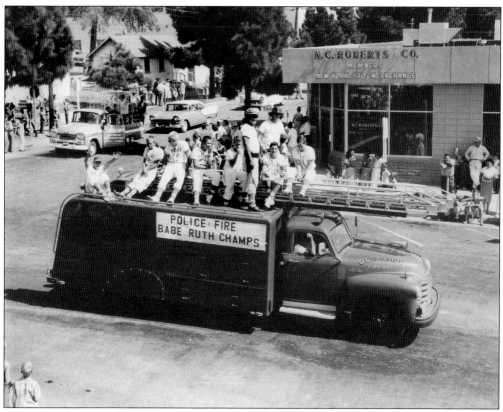

Above, Truck 5 hauls the "Police and Fire Babe Ruth Champs" in a parade. Future OFD firefighter Richard "Hatch" Baxter watches from his Chevy (behind the pickup truck). Below is a group photograph of all firefighting personnel on the OFD in 1959.

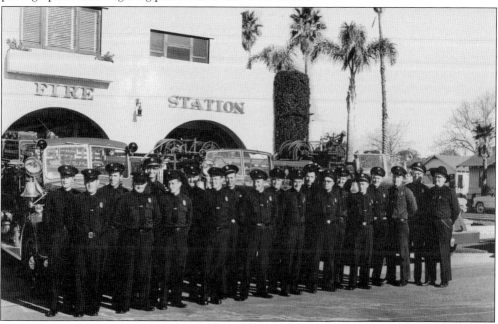

In the early 1950s, the firefighters had a well-maintained goldfish pond and fountain in front of station No. 1. Pictured here, clockwise from left, Capt. Everett Stephens, engineer John Guest, and firefighters Clifford Applegate and Lloyd Seal use the 1946 front-mount pump Dodge fire engine to change the water.

Capt. Richard Trotter (far right) and his crew take an evening break on the bumper of engine No. 1 on the apparatus bay at station No. 1. Pictured below, Dan Piercey (1), Jim Brown (2), Jerry Graben (3), Dick Trotter (4), and Cliff Applegate (5) return to the firehouse after a call. (Below, Oceanside Historical Society.)

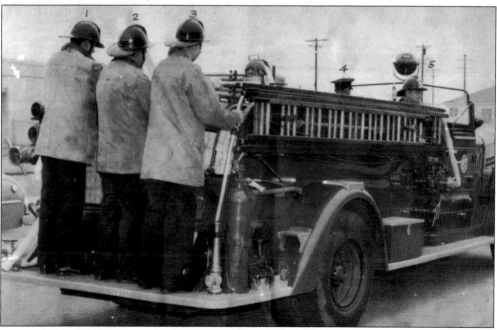

Five

THE COWBOY FIRE CHIEF

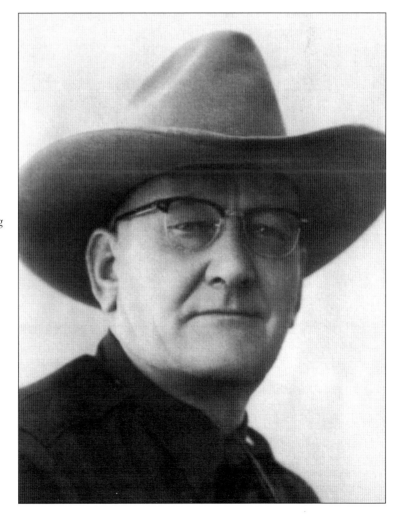

"[Chief Johnson] was a key figure in every important event in Oceanside, [and has] a reputation for being an outspoken and respected authority on a wide range of subjects . . . he is [also] known for his large size, booming voice, flashy cars, dark shirts, broad-brimmed hat, cigar, and frank manner." This quote was from the California State Resolution by former assemblyman Sheridan Hegland at the dedication of Walter Johnson Fire Station No. 1, September 1971.

Chief Johnson, Oceanside's fire chief during its most formative years, was born in Chicago on January 1, 1894, only seven years after the OFD was first founded. In 1908, his family migrated to California, where his father opened a dairy farm in Oceanside's San Luis Rey Valley. Following his father's death in 1935, Walter and his brother ran the 296-acre dairy until selling it for development in 1943. Interestingly, on that vastly developed acreage today (in separate locations) sit both the Oceanside Fire Training Center and Fire Station No. 7. Below is a June 4, 1947, code violation written by Chief Johnson. (Left, W. Johnson family)

Despite the family business, Chief Johnson always had an eye for public service. He was a ranger for the forest service for five years before settling into a career as a firefighter. In 1925, during a reorganization of the volunteer OFD, Ernest White was named chief and Johnson was named assistant chief. On October 10, 1929, he was promoted to fire chief and would be the first paid chief in the history of the OFD. Pictured below, despite his more administrative duties, Johnson remained active in firefighting.

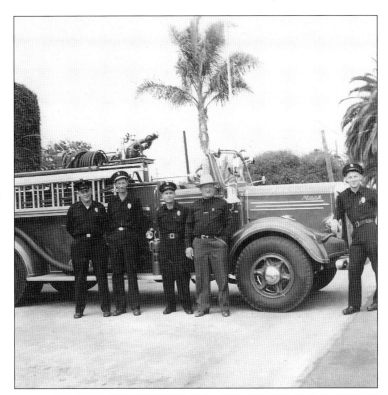

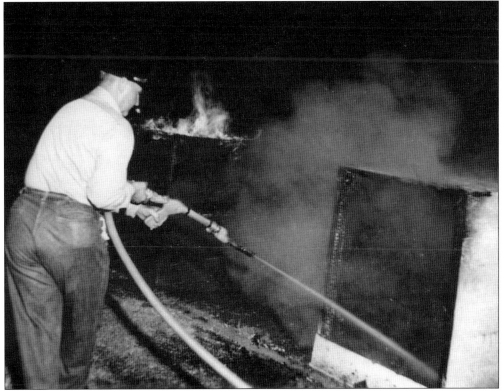

August 13, 1940

Honorable Mayor and City Council
City of Oceanside.

Gentlemen,

 It is felt that the City of Oceanside has grown to the point to where our Department needs additional and larger fire fighting apparatus.
 I would like to suggest that you investigate the possibilities of the purchase of one additional Fire Engine, to be of an approved make, with a water pumping capacity of seven hundred and fifty gallons per minute.

 Such a truck will come, delivered in Oceanside, with basic equipment such as, suction hoses, two small ladders, spot lights, hand operated extinguishers, warning devises (red lights and siren) and windshield.

 Fire Engines similar to the above described, may be purchased from reliable firms on the time payment plan for aproximately $9000.00
 It is my sincere wish that you give this an early consideration.

 Respectfully,

 Walter M. Johnson, Chief
 Oceanside Fire Department.

Chief Johnson was responsible for taking the OFD from hand-pulled hose carts and chemical wagons to the opening of fire stations No. 1 and No. 2, as well as the complete modernization of all fire apparatus. It would seem that his assertive, brash manner was perfectly suited for the era, and he set a precedence for community service that Oceanside firefighters continue to this day. (Below, Edith Swaim.)

Six

THE SIXTIES, U.S. INTERSTATE 5, AND MACARONI FOR LUNCH

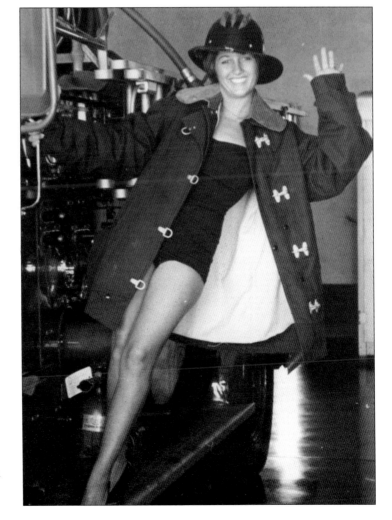

The 1960s saw the expansion of not only the fire department but of Oceanside itself. Fire station No. 3 was opened at the intersection of Oceanside Boulevard and El Camino Real, and the city saw the opening of U.S. Interstate 5, the creation of the Oceanside Harbor, Tri-City Hospital, and Mira Costa College. Also the OFD started a prevention campaign with the creation of a Miss Fire Prevention.

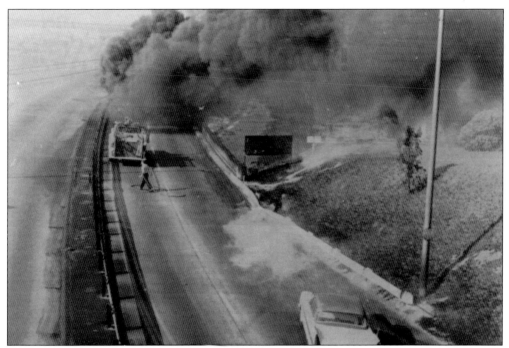

Shortly after U.S. Interstate 5 was opened in the mid-1960s, two fuel tanker trucks collided and burst into flames. The freeway brought a new danger to Oceanside firefighters that has provided challenges ever since. Pictured above, firefighter Jack Rosenquist extends a hoseline in his station uniform. Pictured below, bystanders assist a firefighter dousing the flames on one of the tankers.

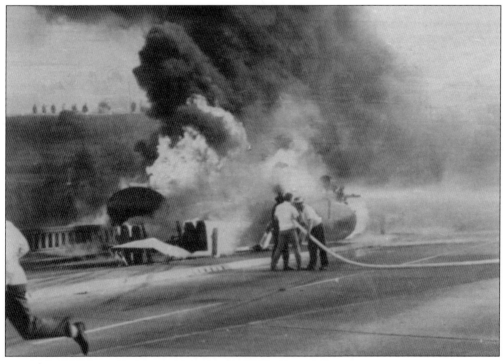

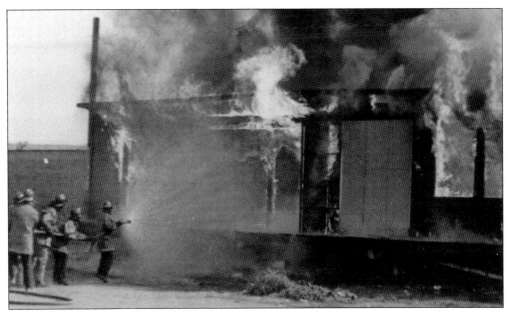

Firefighter Bob Cotton (above, second from right) backs up the nozzleman in this drill burn in the late 1960s at a local packing shed. Standard daytime firefighting gear was a fiberglass helmet, a fire retardant–treated cotton turnout coat, a pair of Frisco jeans, and Wellington cowboy boots. At night, bunker pants replaced jeans to improve safety and response times. Pictured below, firefighter Mike Jennings takes a turn. In the 1960s, breathing apparatus were obviously still a novelty.

Another tradition at the fire department is firehouse meals. Pictured left, Capt. Dick Trotter tests firefighter Jack Rosenquist's macaroni at station No. 1. While not exactly "prison food" (the photograph next to it is the dorm room before the bars were removed), station No. 1 has seen its share of interesting meals over the years. It looks like this meal (below) includes cantaloupe, some veggie sticks, and a cream pie. The victims of this meal are (from left to right) Captain Trotter, engineer George Raue, firefighter Rosenquist, firefighter Dan Piercey, and firefighter Joe Curtis. (Above right, Oceanside Historical Society.)

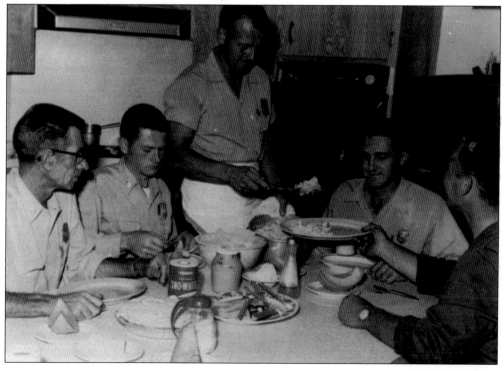

Firefighter Irwin Hedstrom and other OFD members (above) help U.S. Navy corpsmen place a car accident victim into the ambulance. At the time, firefighters were only first aid certified. On October 10, 1962, fire station No. 3 (below) was opened at 3101 El Camino Real. Its building cost was $66,400, four times as much as station No. 1, thirty years earlier.

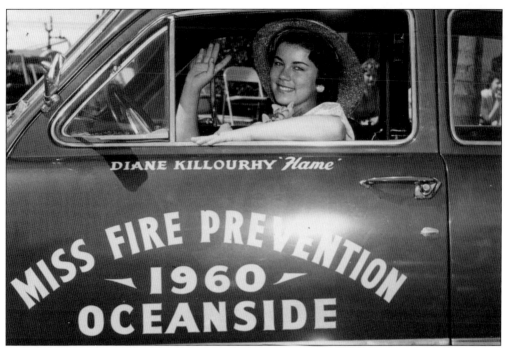

Diane "Flame" Killourhy was one of Oceanside's first women to earn the title of Miss Fire Prevention. She was in the Oceanside High School Class of 1961 with soon-to-be firefighter Frank Imbilli and worked as a secretary across the street from station No. 1. Her red car had been donated from Harold Carpenter's junkyard and, similar to F4, was completely restored by off-duty firefighters, with much assistance from OPD officer L. C. Settle's body shop. Pictured below, Joe Curtis (left), Jack Rosenquist (center), and Jim Oxley welcome Diane to station No. 1.

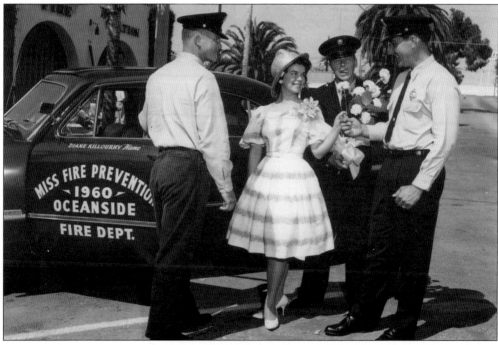

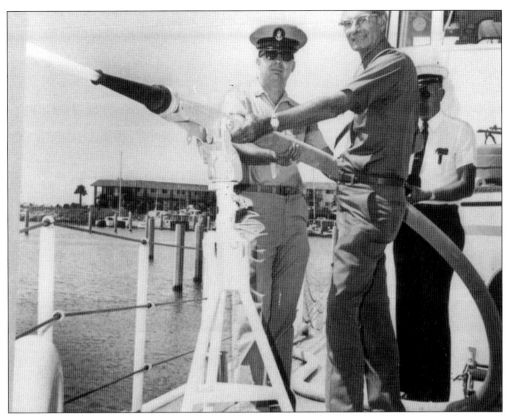

Assisted by the boat's captain, OFD chief Trotter (center) gets the feel for a nozzle mounted on board a U.S. Coast Guard cutter at the Oceanside Harbor while Chief John Guest looks on. Pictured below, an unidentified Oceanside firefighter douses the flames on a boat fire at the harbor with the USCG cutter *Point Hobart* assisting. (Below, Oceanside Historical Society)

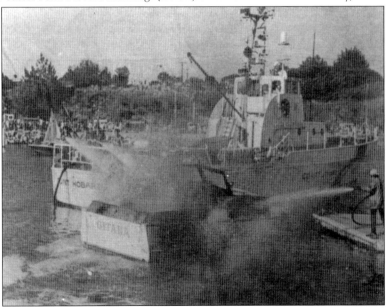

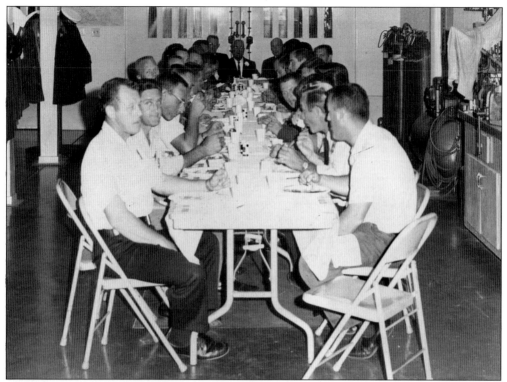

In 1965, the department was small enough to hold retirement dinners on the apparatus floor. This was Jim Hicks' retirement at station No. 1. Note the large swinging double doors that have long since been replaced with modern mechanical rolling doors.

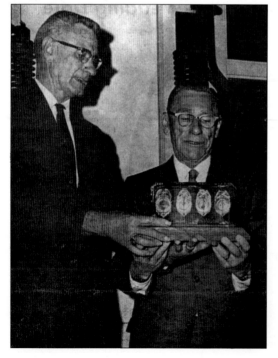

When firefighters retire, it is a tradition to give them back all the badges they earned throughout their career. Pictured below, Chief Trotter presents Chief Everett Stephens with a badge display at his retirement party on February 23, 1969. (Everett Stephens family.)

Seven
SAN DIEGO COUNTY'S FIRST JOHNNY AND ROY'S . . . AND LIME GREEN RIGS

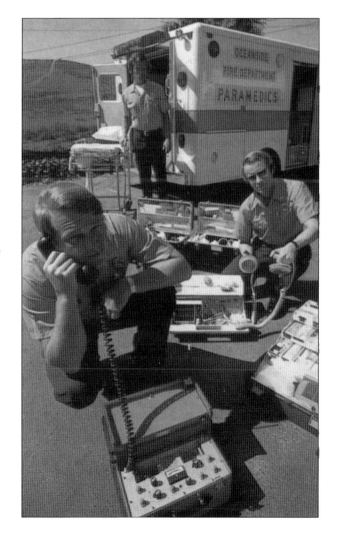

In 1975, the OFD became the first fire department in San Diego County to provide paramedic services. The department had already been providing EMT ambulance service since 1972. Pictured right, firefighter Rich Adams (by ambulance) stands by as firefighter/paramedics Dan Meritt (foreground) and Bruce Kassebaum display some of their Advanced Life Support (ALS) equipment. The mobile phone allowed direct contact with the emergency room doctor at Tri-City Hospital. This new capability allowed firefighters to bring the emergency room into the living rooms of all of Oceanside's residents and guests.

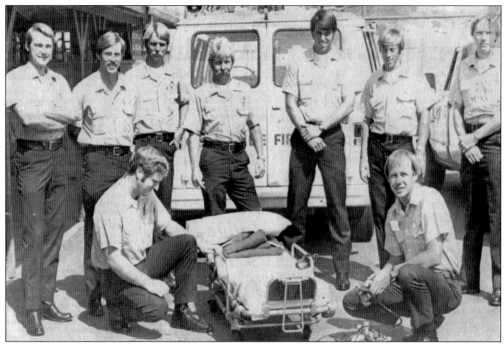

The first class of Oceanside's firefighter/paramedics were, from left to right, (first row, kneeling) Mike Flanagan and Ted Porter; (second row) Dan Meritt, Phil Whitson, Rick Bryant, Bill Harris, Dan Glassey, Jim Myers, and Brian Serafini. They would attend the year-long training program at the University of California–San Diego Medical Center. Pictured below, firefighter Dan Foch (left) assists firefighter/paramedics Ted Porter (center) and Dan Meritt as they practice a simulated medical problem on battalion chief Dick Thompson.

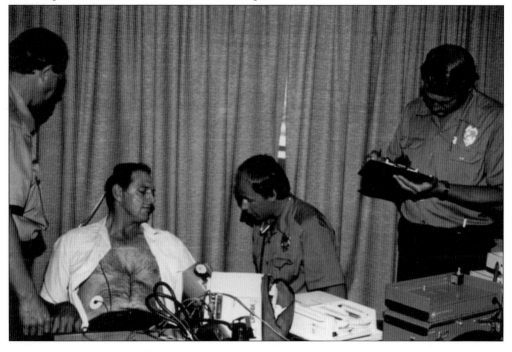

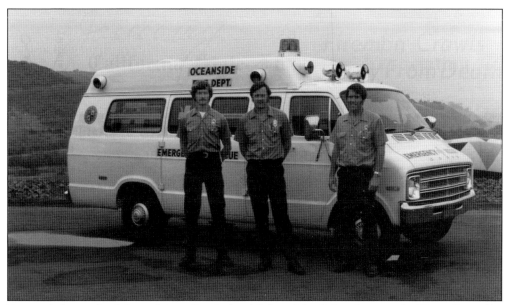

Pictured above, firefighters Marv Smith (middle) and firefighter/paramedic Terry Scott (far right) stand in front of an OFD ambulance in the parking lot of station No. 3. A probationary firefighter, R. "the Praying Mantis" Williams, stands to the left. FF/PMs Keith Collins (left) and Bill Strojny demonstrate the defibrillator paddles on firefighter Dan Hatle. In the photograph below to the right, firefighters Ken "K. W." Ruth (left) and Bob "Mac" McFarland tend to an injured motorcyclist.

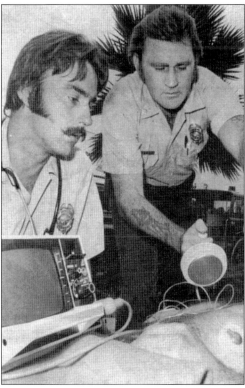
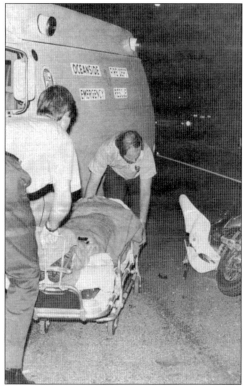

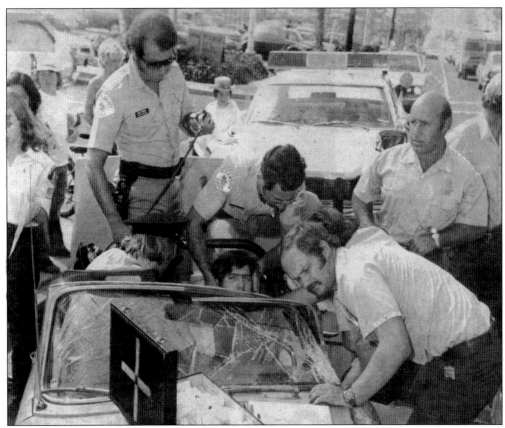

Above, OPD assists Bob McFarland (foreground), Rick Bryant (second from right), and Irwin "Fatback" Hedstrom (far right) as they work for 30 minutes to free a trapped victim at Morse and Hill Streets. Pictured below, engineer Phil Boone, firefighter Joe Urban, and the crew from station No. 3 used the Jaws of Life to extricate the victim of a rollover at the intersection of El Camino Real and Oceanside Boulevard, right in front of the firehouse. (Below, Oceanside Historical Society.)

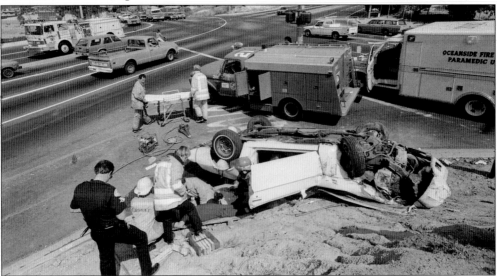

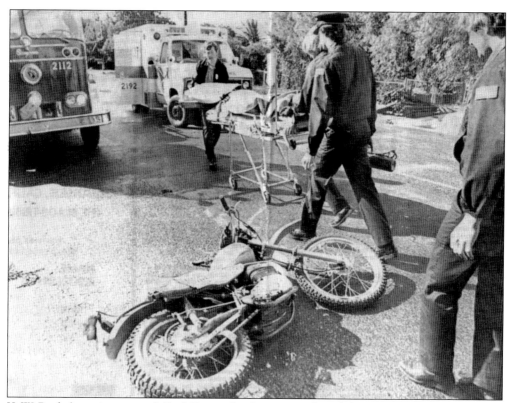

K. W. Ruth (carrying oxygen), Rick Bryant (pushing gurney), and the crew from station No. 2 get ready to transport a victim of a motorcycle accident on the 1400 block of Hunsaker Street. Pictured below, Capt. Bill Betz (second from left) supervises the overhaul of a fire at St. Mary's School.

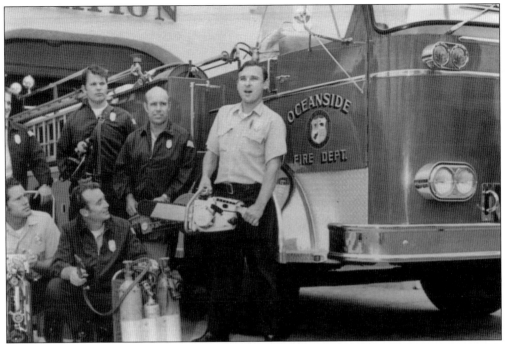

Clockwise from top left, firefighters Jim Spaulding, Gary Schmitz, Irwin Hedstrom, Mike Kirk (with chainsaw), Carlos Buntin, and Richie Lawrence pose with some tools such as a chainsaw, a Homelite XL-88 saw, and an oxy-acetylene torch. Behind them is a convertible 1963 Seagrave pumper. Pictured below, FF/PMs Bill Strojny (left) and Brian Serafini extinguish a shed fire at a strawberry field in the San Luis Rey Valley. (Below, Strojny family.)

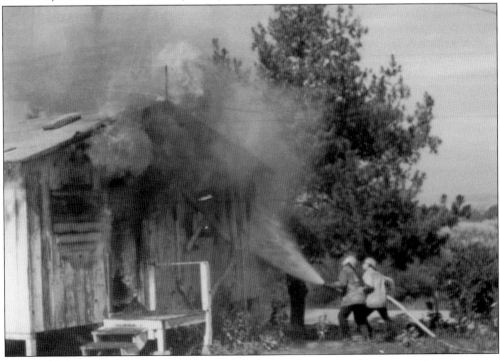

Pictured at right, engineer Harry Hickok (left) and FF/PM Brian Serafini are at an apartment fire. For many years, Harry was the "map guy," responsible for making sure all the apparatus and stations had current and updated maps. Below is one of his hand-drawn maps of station No. 1's district.

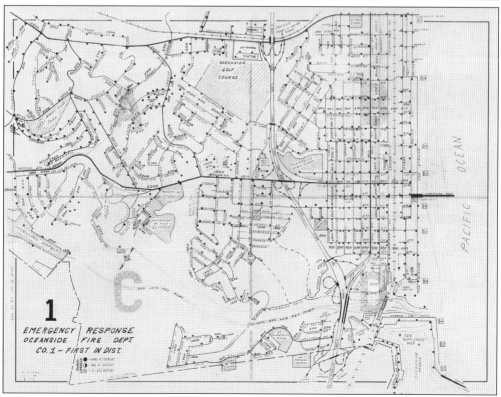

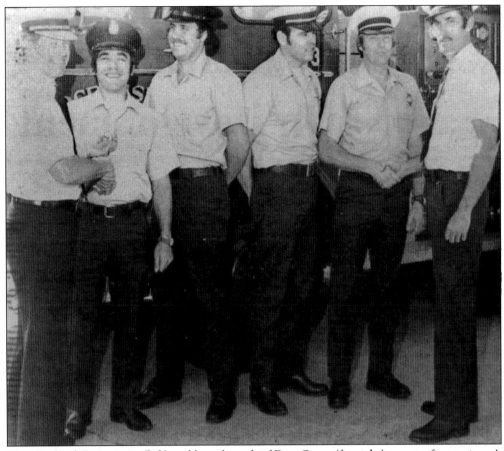

Fire chief Jack Rosenquist (left) and battalion chief Don Guest (far right) present fire engineer's badges to (from left to right) Frank Imbilli and Russ "Bub" Parks and captain's badges to Jim Denny and Lenny Leach. Pictured below, engineers Gerry Gunnarson (background, right) and John "Duke" Wayne (foreground, right) look on as rookies Phil Whitson (left), Bob McFarland (center), and Keith Collins drill in front of station No. 1 in 1974.

On the right, firefighters Jim Love (top) and Bill Betz practice rappelling off of the edge of station No. 1. Pictured below, firefighter Barney Fields, who would later be promoted to battalion chief and become the training officer, demonstrates the XL-88 at an automotive-extrication drill at Hughes Wrecking Yard in the 1970s. From left to right, engineer Gerry Gunnarson, firefighter Brad Anderson, engineer John Goff, Capt. Smiley Morse, and firefighter Frank Imbilli look on. (Right, Bill Betz.)

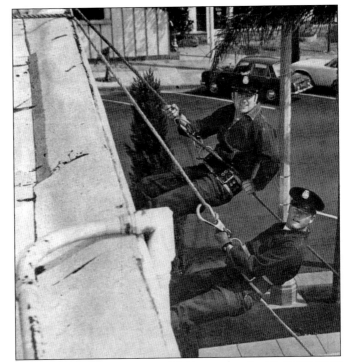

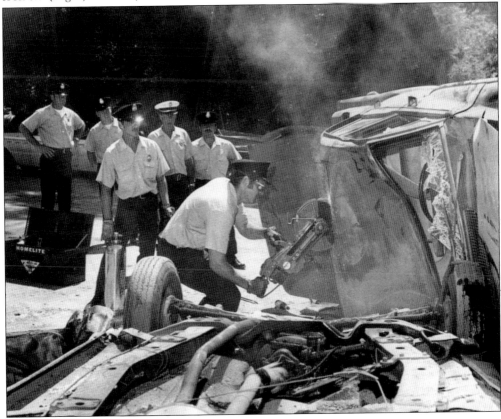

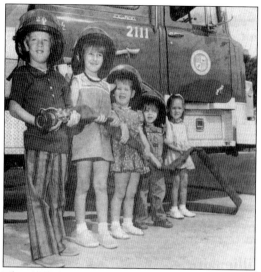

The OFD has always been one big family, and that includes kids and spouses. Chris "Larry" Lawrence (above with the striped pants and nozzle) is retired OFD engineer Ritchie Lawrence's son. His grandfather, Rollin Calhoun, was an OFD captain in the 1940s and 1950s. Chris is now a captain with the Carlsbad Fire Department. At one time, the OFD had a firefighters' auxiliary comprised of the wives of firefighters (above, right). Members included, from left to right (holding hose) Allyson Cotton, Susan Graham, Dana Serafini, and Alicia Contreras. Capt. Rich Armstrong (left) and assistant chief George Raue show them how to operate a firefighting nozzle. Pictured below, Irwin "Fatback" Hedstrom rescues a child locked in a Volkswagen bug.

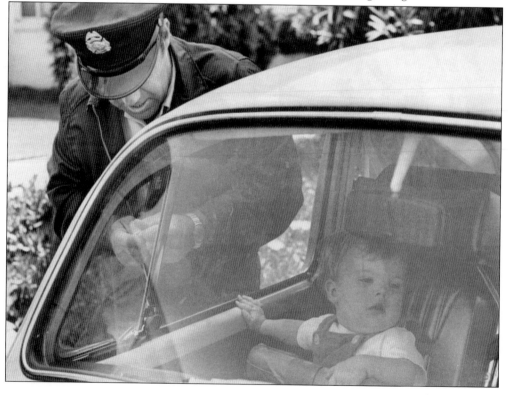

Pictured from left to right, Capt. Jack Francis, engineer Bub Parks, firefighter Mike Theriot, and an unidentified firefighter stand in front of station No. 1 in 1976 with a newer Mack fire engine. Pictured below, from left to right, Alex Obregon, Glen McCloskey, Richard "Hatch" Baxter (thumbs up!), Scott Simpson, Curt Launer, Jerry Abshier, Mike "Angel" Young, and Ken "Gluppy" Love are at battalion chief Curt Launer's retirement party in the late 1970s.

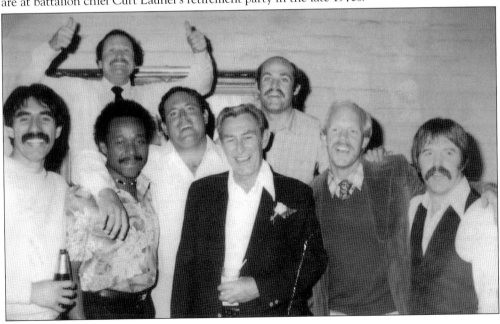

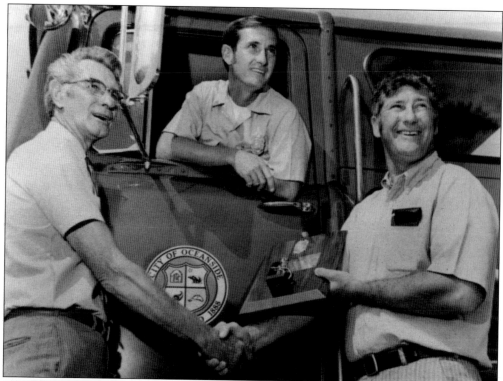

Pictured above from left to right, Chief Trotter and OFA president/engineer Cotton congratulate firefighter Cramer Jackson on his retirement. Pictured below, the administrative staff poses in front of the old fire bell that is now mounted at station No. 1 where the goldfish pond once was. It was first purchased in 1906 when E. L. Stump was the fire chief and was placed in a bellower at First and Freeman Streets. In 1921, it was moved to Fourth and Cleveland Streets. In 1926, an electric siren took its place, and in 1930, it was unceremoniously stored at station No. 1. Thirty-nine years later in 1969, Chief Trotter found the old bell and mounted it in its present location. Pictured with it are (from left to right) assistant chief Raue, fire marshal Ted Wackerman, Peggy Holt, Chief Jack Rosenquist, battalion chief/training officer Curt Launer, executive officer Tom Moore, Pauline "Boots" Johnson, and assistant fire marshal W. "Doc" Longman.

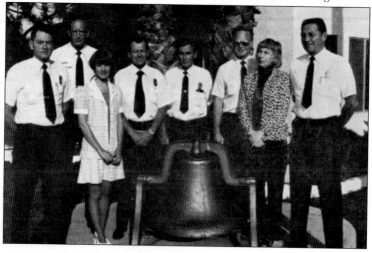

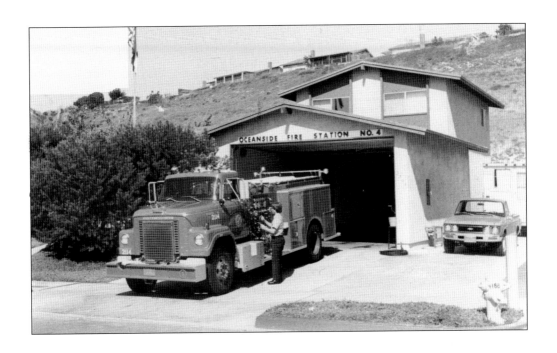

When fire station No. 4 opened at 2797 College Boulevard on October 1, 1971 (at a cost of $35,805), it created the need for more personnel and resulted in promotions. Pictured below from left to right, battalion chief Hank Thompson, congratulates Capt. Mike Kirk and engineers Skip Franklin, Gary Schmitz, Jack Francis, and Bob Cotton on their promotion. Filling their shoes are recruits (clockwise from left) Fick, Gunnarson, Martin, Wayne, Fields, Parks, and Theriot.

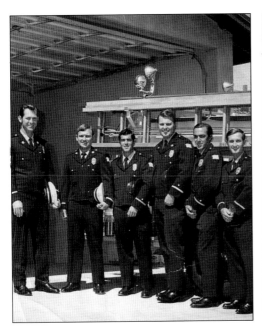
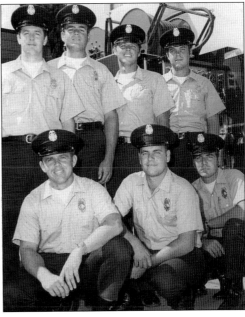

In the late 1970s, some citizens questioned the use of fire engines for going to the grocery store to shop for meals. A cartoon was published that made light of it, and while they were at it, they made a joke of all the different colored fire apparatus in the city. Indeed, new, supposedly more visible lime-yellow rigs had just been added to the current red (and white, including the White Whale) fleet. Also it seems that as time passes, new fire engines just get bigger. When station No. 1 was built, it was designed for the relatively small 1923 American LaFrance. This meant the arches, originally designed by architect Irving Gill, would have to be expanded. On a quiet weekend, the firefighters took it upon themselves to widen the arches, (below) which is how they remain today.

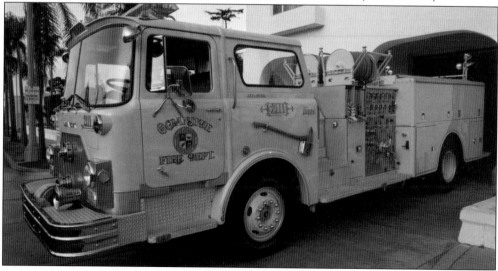

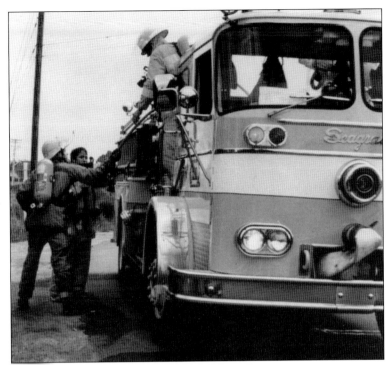

Engineer Ken Love is in the cab of one of the green Seagraves, preparing to pump a pre-connect hoseline being pulled from the side. Pictured below, firefighters Ted Litchfield (left) and Bill Betz check out the turkey for their Thanksgiving dinner at station No. 2. (Below, Bill Betz)

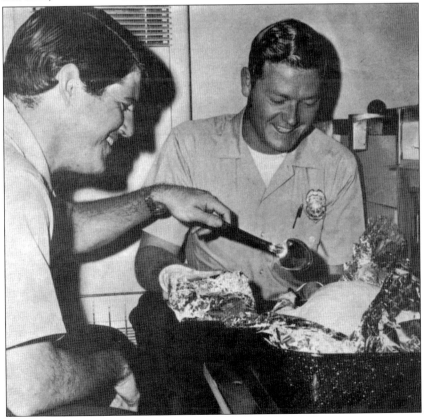

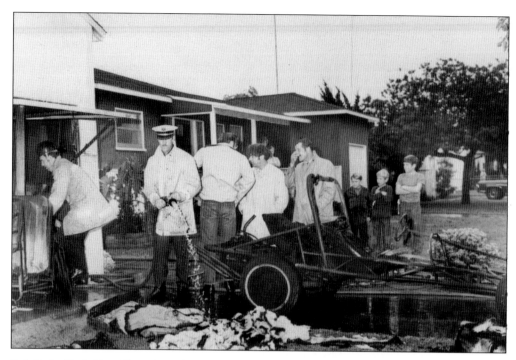

Bub Parks (far left) and battalion chief Don Guest (who was known to wear his white cap no matter what) mop up a garage fire at firefighter Jim Love's house while firefighter Frank Imbilli (fourth from left) and engineer Richard "Hatch" Baxter (fifth from left) look on. Boxes of ammunition kept exploding as they were attempting to extinguish it. Pictured below on the left, K. W. Ruth (left) and Don Guest (white cap) help extricate victims trapped in their Volkswagen bug after unsuccessfully trying to outrun the railroad crossing arm . . . and the locomotive. To the right, K. W. mops up after a motel room fire.

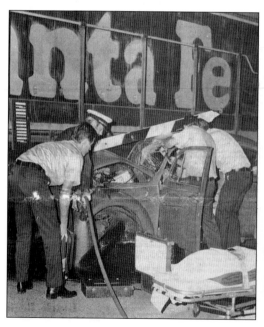

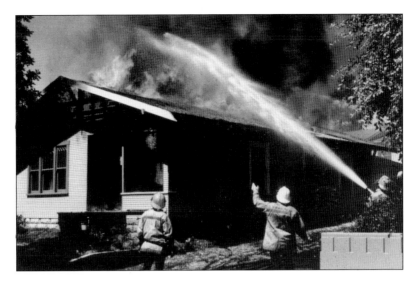

Battalion chief Hank Thompson directs his crew in an attempt to extinguish a roof fire.

Pictured to the left, battalion chiefs Don Guest (left) and Tom Moore discuss strategy at an apartment fire.

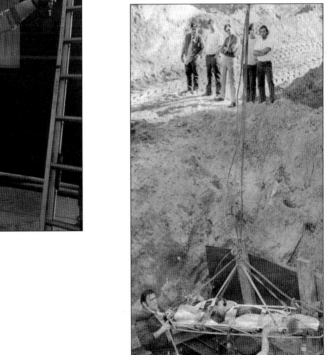

Firefighter Bill Strojny steadies the stokes basket (to the right) during a trench rescue.

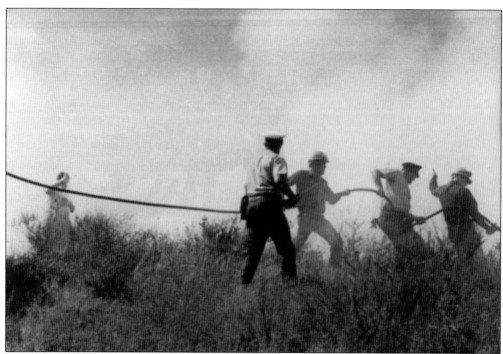

Battalion chief Don Guest (white cap!) helps advance a hoseline on a fast moving brush fire during Santa Ana wind conditions in September 1970. Capt. Joe Gregory, who was off duty, stopped by to lend a hand. During the fire, Gregory rescued a turtle, shown here along with Jack Francis. Pictured below, "Oscar" became a Gregory family pet and went on to live a long life. (Below, Joe Gregory family.)

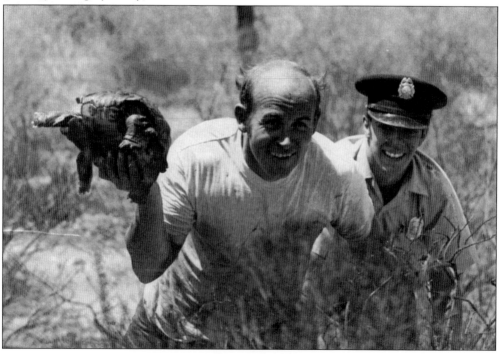

Eight

The Rodeo Years

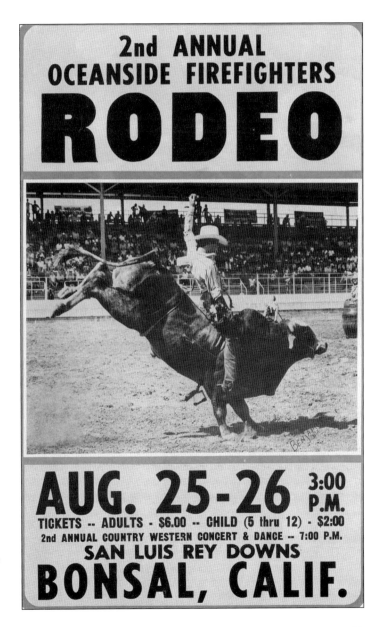

For three years, starting in 1984, the Oceanside Firefighters Association hosted a full-blown professional rodeo event. Held at the San Luis Rey Downs, they even had Hank Williams perform one year. (Bill Betz.)

Part of hosting the event included operating the concessions and a beer garden. Pictured above, engineer Ed Golden (left) and Capt. Bill Harris prep one of the beer stands. Below are Capt. Dennis Tico (left) and engineer Mike Monreal.

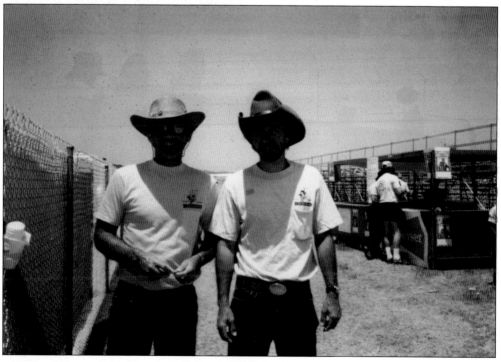

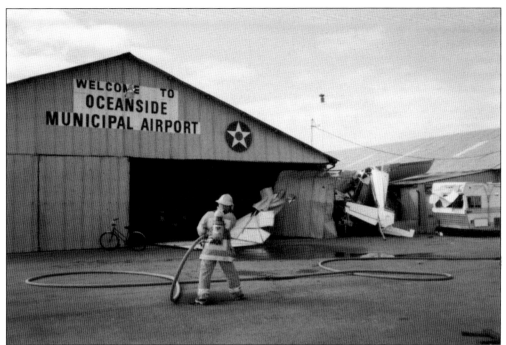

A small plane crashed into a hangar in 1989 at the Oceanside Airport. Pictured at right, Capt. Bob Cotton suspends himself from FF/PM John Strock at station No. 3 during a truck drill with firefighter Jim Mohrman looking on, evidently unimpressed.

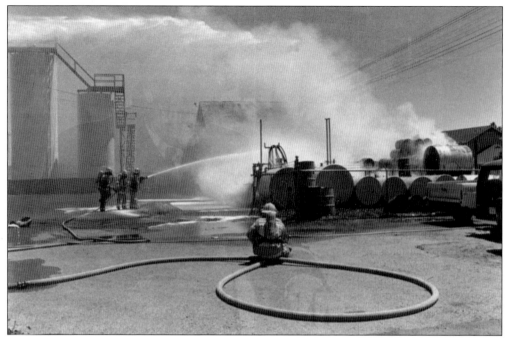

Oceanside fire crews knock down flames at the Shell Oil Fire in May 1988. First in, Capt. Dennis Tico (unseen) is directing another hose stream from the opposite side.

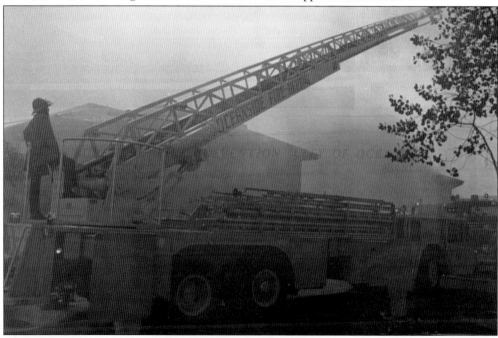

With the presence of large structures such as the Tri-City Medical Center and the Marina Towers, the OFD purchased a 1977 Van Pelt 100-foot aerial ladder truck. One of only two ever built, it had an Oshkosh Low Profile chassis, which gave it a unique, lowrider look. Shown here at a working fire, its expenditure of $206,000 was more than the building costs of the OFD's first four fire stations combined.

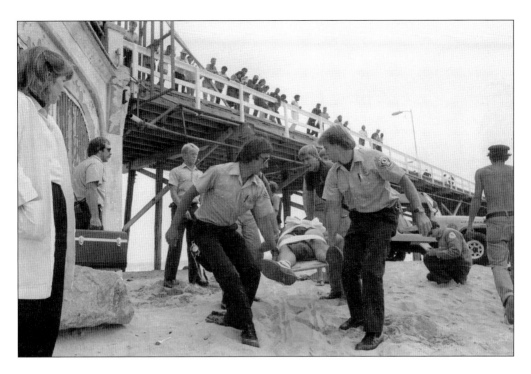

Pictured above from left to right, FF/PM Eric "EO" Osterberg, engineer Keith Collins, and FF/PMs Mike Mathai and John Bruce render aid to a man who jumped from the pier onto the sand. Capt. Phil Whitson is carrying the trauma box. Pictured below, crews respond to a boat fire exercise at the Oceanside Harbor in 1984. (Both, Oceanside Historical Society.)

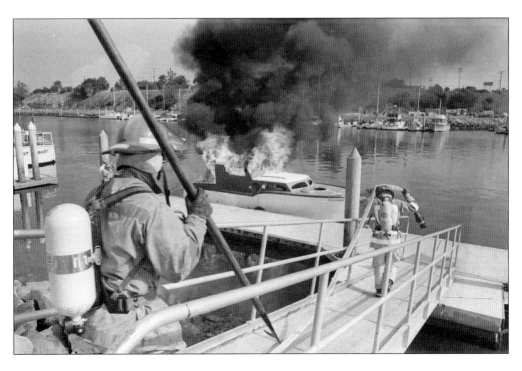

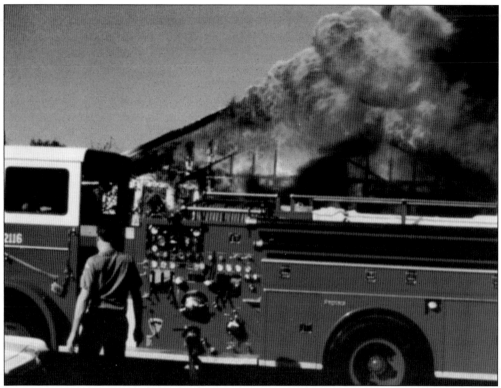

Firefighter K. W. Ruth rushes to relocate an engine parked too close to the raging house fire. Pictured below, K. W. (right) and engineer John Goff overhaul a burned-out structure.

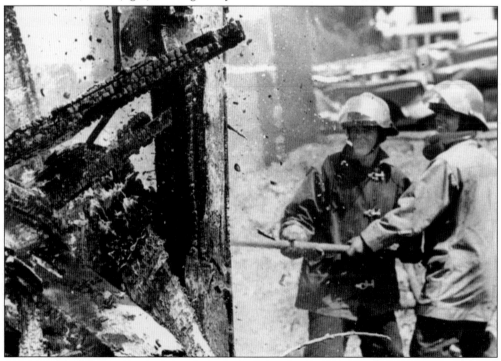

From left to right, FF/PM Mike Young, Capt. Charlie Scism, engineer Dan Hatle, and FF/PMs Mike Jennings, Joe Urban, and Gary Weimokely are posing for the camera after a call as Hatch Baxter (below, foreground center) and his crew uses the Jaws of Life to rescue a trapped victim.

Oceanside firefighters are on the roof of a house fire on Dubuque Street in the mid-1980s. Pictured below, the B shift poses with brush 1 at station No. 3 in the early 1990s. Pictured are, from left to right, (first row) FF Tom Schraeder, Capt. Mike Jennings, FF/PM John Walkup, engineer Bob McFarland, FF/PM Eric "E. B." Bertotti, Capt. Jim Mohrman, FF Tim "Rodan" Probart, FF/PM Terry "TC Boy" Collis, engineer Keith Collins, FF/PM Eric Osterberg, FF K. W. Ruth, FF/PM Jerry Boosinger, and battalion chief Dick Thompson; (second row) Capt. Hugh Fleming; engineer Rick Bryant; FF/PM John Bruce; Capts. Bill Harris, Phil Whitson, and Rich Armstrong; and engineer Ken Love; (third row) FF/PMs Bill "B. K." Kogerman, Chris "C. T." Tucker, Mike Margot, and Mark Mollet; and engineer Marv "Bullwinkle" Smith. (Above, Oceanside Historical Society.)

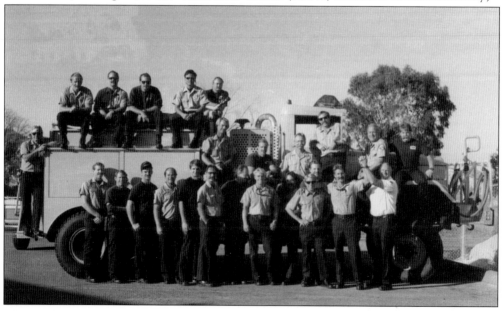

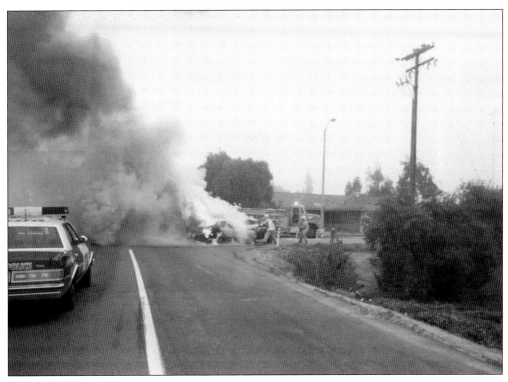

An OPD cruiser stands by as the crew from station No. 4 knocks down a car fire. Pictured below from left to right, FF/PM Stu Sprung, engineer Marv Smith, FF/PM Dominic Smith, Capt. Joe Ward, and FF/PM Greg deAvila take a break after a commercial drill burn on the north end of Hill Street in the mid-1990s.

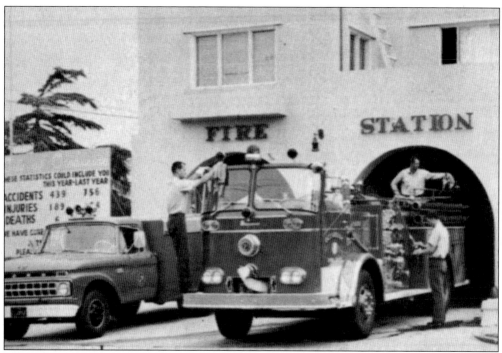

This open-cab, 1963 Seagrave served the citizens of Oceanside for over 20 years. At one point, a fiberglass top was added. It was eventually donated to the Cabo San Lucas Fire Department at the very southern tip of Baja California, Mexico. The OFD had a special bond with Cabo, with almost all of the firefighters from this era having made the journey at least once for the legendary "Brad and Hatch" fishing trips. Brad "Sunfish" Anderson and Hatch Baxter spent almost two months every year, for 15 years, fishing marlin and camping at the Vagabundos Del Mar campground with their fishing boats. OFD members always had an open invitation. Pictured below from left to right, Hatch, Mark Finstuen, Glenn Smith, Dennis Rogers, and Tom Schraeder visit the old Seagrave in the early 1990s on one such fishing trip.

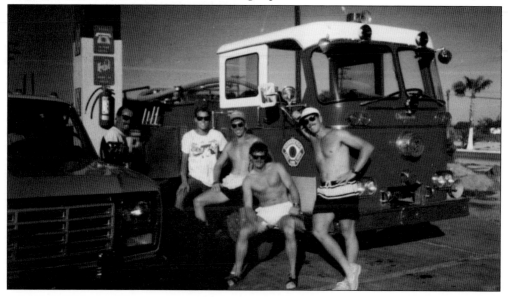

The photograph above was taken on FF/PM John Walkup's birthday outing . . . except he fell ill at the last minute and could not make his own party. It looks like his B-shift brothers made out okay regardless. Starting second from left, Bill Harris, Marc Pearson, Joe Ward, Darryl Hebert, Hugh Fleming, Bill Kogerman, Mark Finstuen, and Terry Collis pose with their catch. Pictured to the right, Richard "Hatch" Baxter cares for a child involved in a car accident on Hill Street. Capt. Ken Matsumoto is standing behind him. (Right, Mark W. Finstuen.)

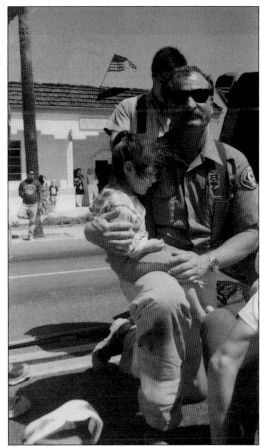

The OFD was one of the first fire departments in the country to have MDTs (Mobile Data Transmitters) in all fire apparatus. They allow call information to be routed directly to the captain's monitor. Pictured here, Capt. Bill Betz pulls up a response. Nearly every fire department utilizes them now.

Oceanside firefighters have always been active in charities, such as the San Diego County Burn Run. Here in 1994, from left to right, FF/PMs Dale Stewart, Joe Ward, Bill Hoffman, and Mark Finstuen join fire chief Dale Geldert as he presents $2,300 to the San Diego County Burn Institute so burn-injured children can attend the summer burn camp.

One of the largest fires in the early 1990s was the Furniture Store Fire on South Hill Street. In the December 1997 issue of CSFA's magazine, the OFD was the Fire Department in Focus, and they used a photograph of that fire for the cover. Pictured below, FF/PM Stu Sprung assists an official for the offshore powerboat races in 1996 at the Oceanside Harbor. The man had slipped and was injured when he fell on the wet jetty. Lifeguard sergeant Bill Curtis assists. Bill's father was 1950s-era OFD firefighter Joe Curtis. (Right, Mark W. Finstuen.)

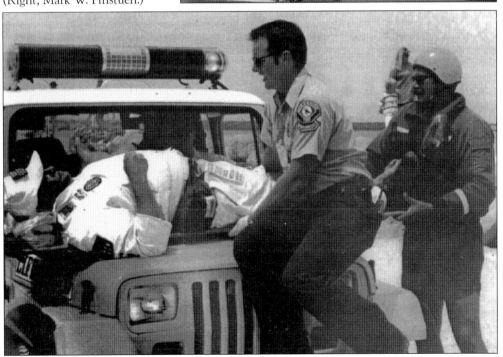

A C-shift group photograph at station No. 3, around the early 1990s, shows (first row) engineer Rick Bryant, FF/PM Ray Melendrez, engineer Hatch Baxter, and FF/PM Glenn Smith; (second row) battalion chief Bob Cotton, engineer Dick "Dickie-Doo" Rummel, Capt. Jerry Abshier, engineer Brad Anderson, FF/PM Joe Urban, and firefighter Terry Scott; (third row) FF/PM Guy "Pumpkinhead" Goodwin and FF/PM Rick Varey. Pictured below, the crew from station No. 3 rescues a trapped occupant from a vehicle accident on U.S. Highway 78. Capt. Dave Snyder supervises as FF/PM Stu Sprung and engineer Keith Collins (right) use the Jaws of Life to pry the car door open. FF/PM Kurt Krebbs is in the background with a California Highway Patrol officer.

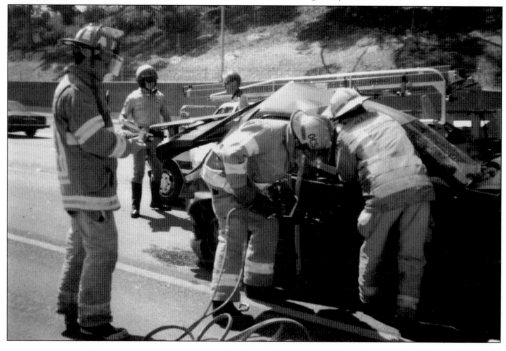

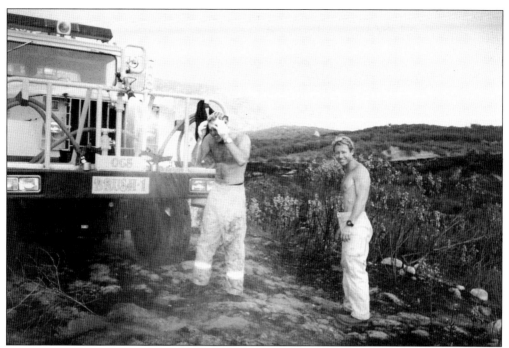

After 36 hours of various wildland firefighting assignments at this brush fire outside of Palm Springs, the crew of OFD's brush 1 was assigned the overnight "fire watch" in a remote area. FF/PMs Stu Sprung (left) and Kirk McCauley make use of the front nozzle to sneak in a little evening shower.

Surf outings are a common occurrence at the OFD. Fire department personnel pictured at this one are, from left to right, Brian Serafini, Ed Golden, Glenn Smith, Jim Emanuel, Guy Goodwin, Rick Bryant, Eric Bertotti, Scott Stein, Bob Miller, Bill Harris, Eric Osterberg, and Dominic Smith. Mark Mollet (left) and Terry Collis are in front.

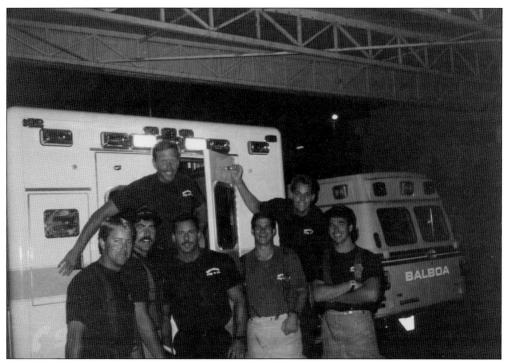

It is late night at the emergency room patient unloading ramp at Tri-City Medical Center, and the boys are all smiles. Pictured are, from left to right, FF/PMs Kurt Krebbs, Scott Prestie, Rick Varey, Eric "Littlehead" Thorson, Mark Finstuen, and Glenn Smith. Firefighter Tom Schraeder is standing on the bumper.

Capt. Kurt Krebbs had one of the rarest senses of humor imaginable. One of his masterpieces was this dig on fire department engineers on this August 1995 "White Issue" of *Fire Engineering* Magazine. While most personnel saw it as pure comedy, he actually succeeded at upsetting several of the senior engineers, which made it even funnier.

Nine
WWW.OSIDEFIRE.COM

The modern-day Oceanside Fire Department continues to carry on the traditions and values passed down by the firefighters chronicled in this book. Today's force of well-trained, motivated firefighters will assure that the uniqueness of the OFD will be carried on for years to come.

In 1906, Oceanside fire chief L. W. Stump gathered up a loose group of volunteers and gave them permanent job assignments: nozzleman, hoseman, connecting hoseman, ladderman, and policeman. Over 100 years later, the OFD has standardized those assignments so that (other than policeman) every firefighter can perform any task. The Oceanside Fire Academy (at a graduation ceremony above), which started in 1999, has graduated six full classes of firefighters. Another enhancement to the OFD has been the creation of an honor guard unit. Pictured below from left to right, founding honor guard captain Bill Hoffman, honor guard captain/fire inspector Ron Owens, FF/PM Alex Cantacessi, and Capt. Dale Stewart perform the opening ceremonies at a Padres game.

Fire chief Darryl Hebert (second from right) stands with the division chief staff at the Oceanside Fire Training Center: (from left to right) Ray Melendrez, Mike Margot, Mike Mathai, and Ken Matsumoto. Three platoons are run by three on-duty battalion chiefs based out of fire station No. 7. Pictured from left to right are Bob Cotton, Pete Lawrence, and Rob Duhnam. And while the fire inspectors keep the city from burning down, the administrative staff keeps everything glued together. On the porch of the infamous *Top Gun* house on Pacific Street are courier Cindy Uyeji, administrative secretary Gracie Ramirez, ATO/nurse coordinator Lynne Seabloom (seated), fire inspector Marlene Donner, fire inspector Greg Van Voorhees, and account specialist Bev Shapiro. (Not pictured are senior office specialist Jan DesRosiers and inspector Ron Owens.)

109

The A-platoon crew from Walter Johnson Fire Station No. 1 stand on historical Third Street, looking towards the ocean at the end of the street. Pictured from left to right are FF/PM Tim Scott, engineer Matt Price, Capt. Bill Kogerman, and FF/PMs Eric Hanson and Daniel Gonzales. First built in 1888, and rebuilt six times after that, the 1,942-foot Oceanside Pier is the longest wooden pier on the west coast. The 1-B crew standing in the foreground are, from left to right, Capt. Eric Bertotti, FF/PM Cory Hawk, engineer Clint Dyal, and FF/PMs Wes McGee and Jess Specht. (Above, Paul Hogan.)

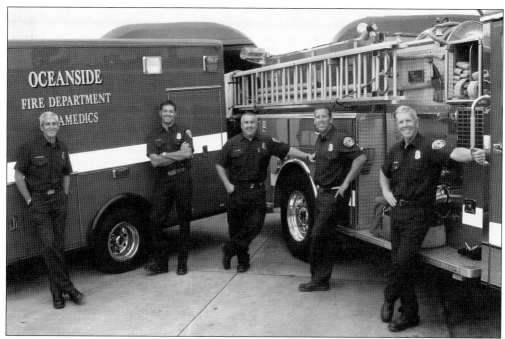

Like generations of firefighters before them, (from left to right) Capt. Mark Sheldone; FF/PMs Bryan Howell, Dan Karrer, and Geoff Merzanis; and engineer Tom Schraeder take a time out in front of station No. 1. In the early 2000s, the OFD had a SWAT Medic Program. Attached to the OPD SWAT team, this specialized group of fire department personnel was certified to function on the primary entry team on SWAT incidents. Pictured here at a drill are (from left to right) SWAT medics Kirk McCauley, Mark Rowe, and Joe Ward. Pictured on the right, FF/PMs Daniel Gonzales (left) and Eric Hanson are dwarfed by an SK-64 Erickson Skycrane Helitanker while waiting for an assignment at base camp on a Southern California strike team.

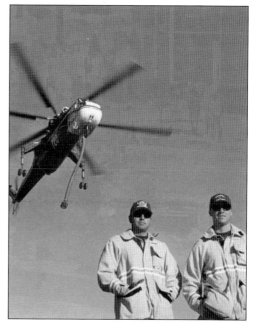

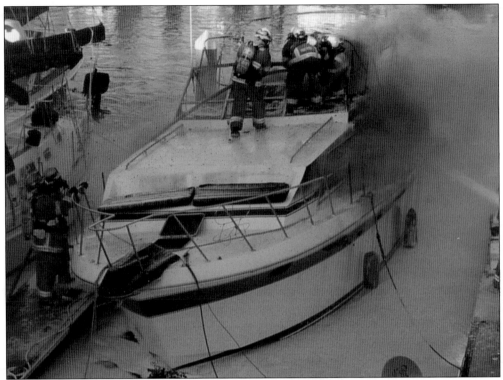

The Oceanside Harbor creates unique challenges for the OFD. Pictured here, firefighters knock down a boat fire. The San Luis Rey River, which opens out to sea next to the harbor, has its own hazards. Oceanside crews extend a progressive hoselay on another riverbed fire.

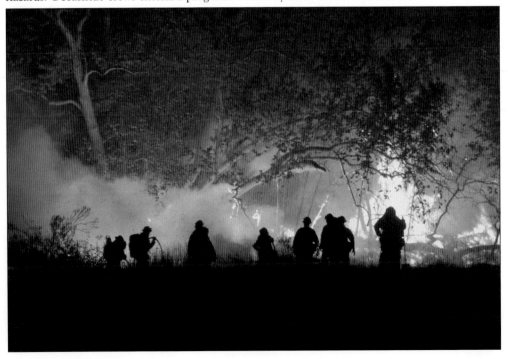

Station No. 2 in South Oceanside has always been considered the prize assignment of the OFD. From left to right, FF/PM Bill Hoffman, Capt. Glen Morgan, and engineer Rich Adams stand in front of station No. 2 with the new sign sporting a "South-O" rocker. One of the appeals of station No. 2's district is Buccaneer Beach. In this photograph, from left to right, Capt. Dan McCauley, engineer Mark Rowe, and FF/PM Chris Tucker check for sand erosion. And back at the station, Capt. Jim Mohrman (left), Capt. Andy Stotts (center), and engineer Dan Foch prepare to pull out of station No. 2 to respond to a public assist call. Shortly after this photograph was taken, Captain Morhman retired and Andy was promoted in his place.

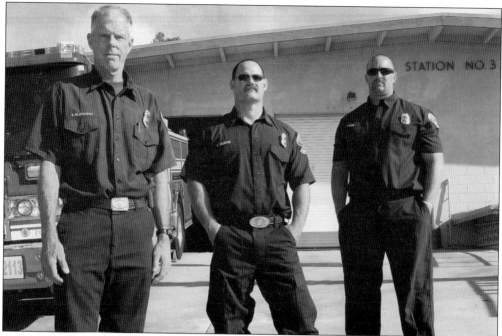

For over 40 years, fire station No. 3 has protected central Oceanside. Pictured here from left to right, engineer Scott Blawusch, Capt. Dave "Dave-O" Overton, and Jason "The Swede" Baker stand on the apron out front. Pictured below, engineer Pete Forbes (left), FF/PM Brian Morrison (center), and Capt. John Bruce are in the station No. 3 apparatus bay, awaiting another night call.

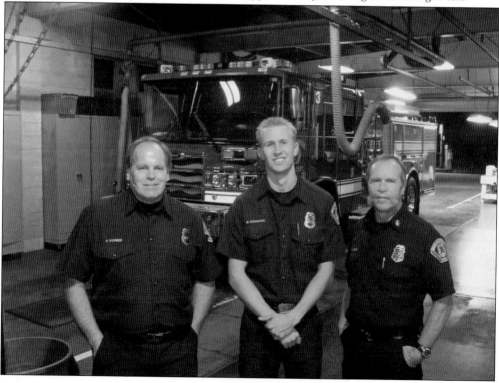

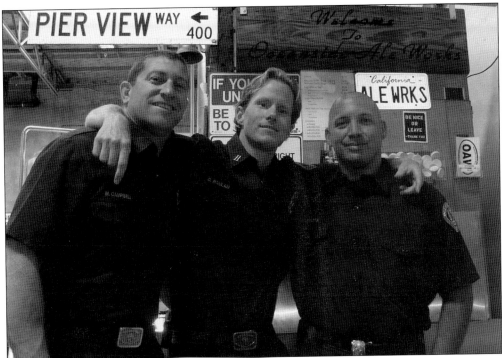

In 2005, OFD engineer Scott Thomas cofounded the popular Oceanside Ale Works, just a short trip down Oceanside Boulevard from station No. 3. Since then, Scott has provided an amazing location for events and thousands of dollars in proceeds to various fire departments and local charities. Here engineer Mark Campbell (left), Capt. Christian Boulan (center), and FF/PM Felix Urrutia swing by to make sure that all is up to code. Below and to the left, the crew from fire station No. 3 assists the Haz-Mat crew at an overturned tanker crash at U.S. Interstate 5 and U.S. Highway 78. Pictured at right, Capt. Hugh Fleming (far right) and his crew on truck 2176 assist engine No. 3 at a commercial Haz-Mat fire in the San Luis Rey Valley.

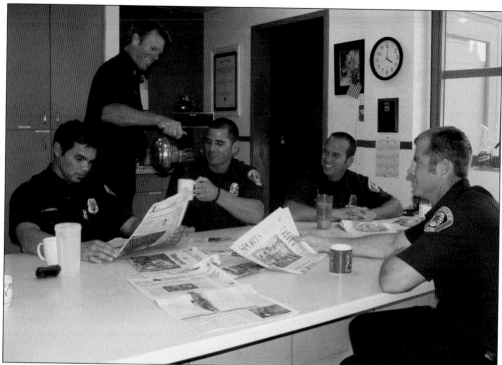

In the mid-1990s, old station No. 4 on College Boulevard was shuttered and a new, modern version was opened to better serve residents in the southeastern part of Oceanside. Pictured here, Capt. Roland Dechaine serves his crew during a coffee break. Sitting, from left to right, are FF/PMs James Thompson, Jeff Cummings, engineer Adrian Corrales, and FF/PM Garret Safe. Pictured below, from left to right, FF/PM Mark Barnett, engineer Justin "Kloppy" Klopfenstein, Capt. John "Johnny Ringo" Walkup, and FF/PMs Anthony "Texas Ranger" Walker and Alex Cantacessi stand outside station No. 4. Lake Boulevard leads away behind them.

With a modern, life-saving "boundary-drop" emergency dispatch system adopted between neighboring cities, many Oceanside units frequently find themselves responding into them. After one such call, the station No. 4 B crew of FF/PM Rich Molina, engineer Scott Bowers, FF/PM Jason Trevino, Capt. Eric "Capt. E. O." Osterberg, and FF/PM Chris Vaughn stop to represent part of their first-in district. In the late 2000s, the OFD took possession of a Type-3 State Office of Emergency Services brush truck. While the state owns the apparatus, the agreement calls for OFD firefighters like Eric Hanson (left) and Tim Scott (right) to maintain and respond statewide if called upon, which has already occurred several times. Pictured below on the right, battalion chief Pete Lawrence (left) and Capt. Dan Meritt accompany the old 1977 Van Pelt ladder truck to Samoa to train Samoan fire crews on how to operate it. They practiced aerial operations by picking coconuts.

 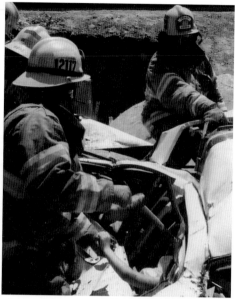

Capt. Dale Stewart and his station No. 5 crew stand in front of the original *Blade-Tribune* newspaper building at Heritage Park. In the OFD, the *Blade-Tribune* was infamous for the 1924 article that prompted the purchase of OFD's first motorized fire apparatus. Pictured with Captain Stewart (middle) are FF/PM Tim Huerta (left) and engineer Rick "The Suitcase" Varey. FF/PM Tim Huerta holds the hand of a little girl as they work to free her and her mother from their car, which was crushed by a rollover dump truck. Both of them survived, with surprisingly minor injuries. And in 2007, the firestorm that swept through San Diego County kept Oceanside firefighters busy throughout the county for days on end. Pictured below, a large brush fire at Camp Pendleton nips on the border of Oceanside. In the foreground is fire station No. 7.

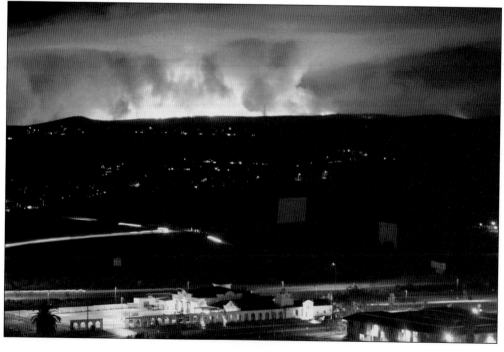

Ever since the opening of the world's largest U.S. Marine Corps Amphibious Training Base in 1942, crews from Oceanside have responded to Camp Pendleton hundreds of times for incidents ranging from full-scale brush fires to vehicle accidents. Pictured here, Capt. Mark Finstuen (left), engineer Scott Thomas (center), and FF/PM Lucifer Keener stand in front of the legendary 1st Marine Division Headquarters. Fire station No. 5 on N. River Road was opened in 1973 to serve the "back gate" area of Oceanside, known by that name because of its proximity to the back-gate entrance of Camp Pendleton. Pictured in front of station No. 5 are, from left to right, engineer Jim Emanuel, Capt. Dave Parsons, and FF/PM Rick Goetz.

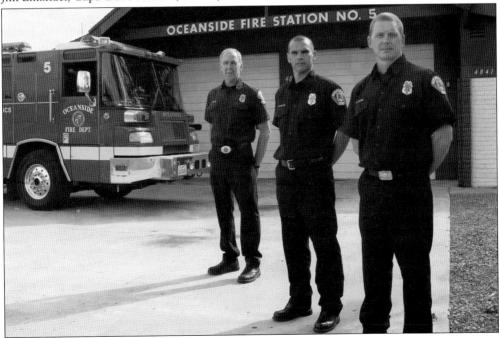

Fire station No. 6, which opened in the late 1990s, was specifically located to serve the far eastern end of Oceanside. From left to right, Capt. Joe Ward, engineer Jeff Driessen, and FF/PMs JP Neilson, Hayden Harshman, and Ryan Robinson stand in front of truck 2176. Pictured below, truck 2176 helps fight a large commercial fire in Escondido, California, as medic 2196 pulls up to a rare middle-of-the-day raging house fire at the intersection of Alamosa Park Drive and Oro Grande.

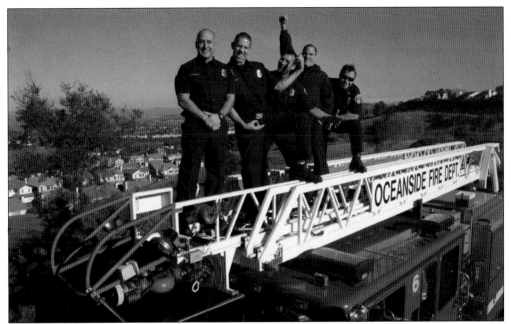

Station No. 6 serves a large rural area. From left to right, FF/PMs Gerhard Vilogron, Marshal Minogue, and Mark Miller; engineer Todd Hunt; and Capt. Kirk McCauley are on the aerial ladder with the rolling Henie Hills behind them. And aside from Bob Cotton, Capt. Hugh Fleming (below, far right) is the last remaining member of a proud generation that first witnessed the advent of firefighter/paramedics in Oceanside, as well as the opening and closing of old fire station No. 4 on Lake Boulevard. Here he is pictured with his crew at station No. 6: (from left to right) FF/PMs James Frank and Steve Choi, engineer Josh Henry, and FF/PM Bobby Castillo.

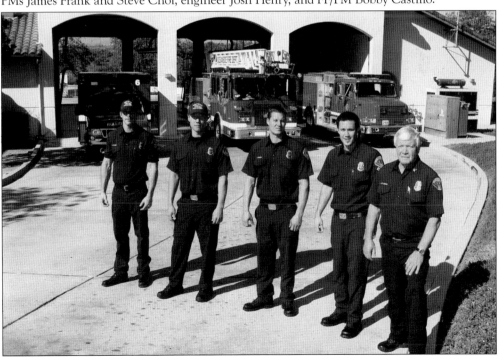

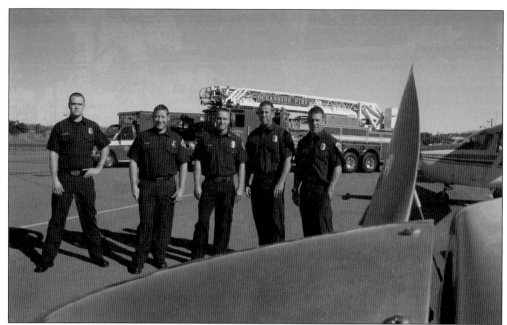

Fire station No. 7's district covers the Oceanside Municipal Airport. Pictured here, from left to right, FF/PM Mike Farnham, engineer Brian Myers, Capt. Terry Collis, and FF/PMs Geoff Merzanis and Chad Cox peer over the nosecone of a Piper. And on July 19, 2008, the new $8 million fire station No. 7, located a stone's throw from the historic San Luis Rey Mission, was officially opened after over a decade as a temporary station in a trailer at the fire training center. From left to right, engineer Tony Chapman, FF/PM Scott Stein, Capt. Greg deAvila, and FF/PMs Tim Badillo and Rocky Rehberg stand on the station's large apron

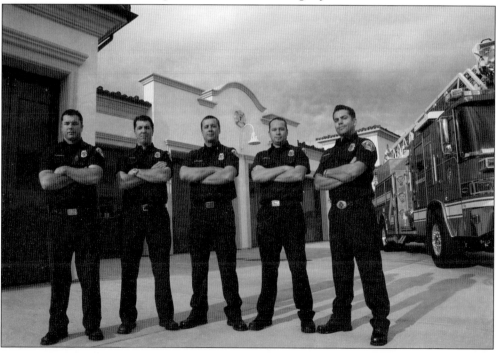

From left to right, FF/PMs Jeremy Brandt, Blake Dorse, Capt. Dave Snyder, FF/PM Eric Nicol, and engineer Lloyd Martinez gather near the 1,000-gallon-per-minute nozzle on the tip of the aerial ladder of truck 2177. While Capt. Dennis Rogers (left) and engineer Ken Love warm up on their drum and pipes, FF/PM Mike Bowman (left), Capt. Scott Prestie (center), and engineer Ian Shelton check out the Oceanside Harbor. The harbor, opened in 1963, is one of the most popular destinations in North San Diego County.

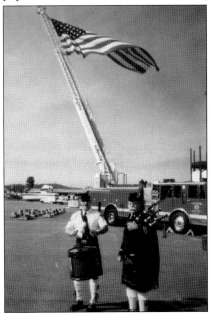

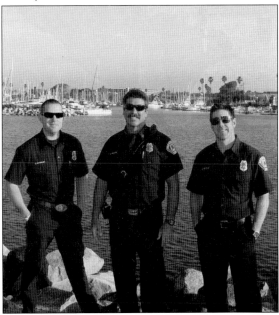

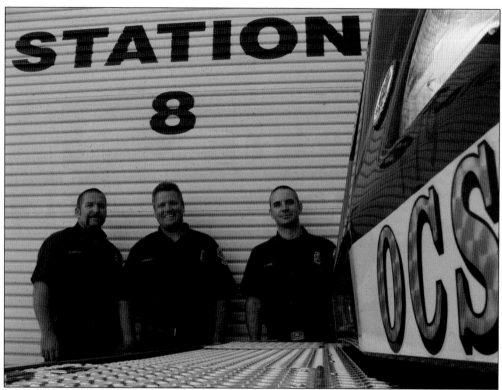

Temporary station No. 8 opened in March 2006 and is located at the city operations center on the east side of the city on Oceanside Boulevard. Pictured here in their spartan space are, from left to right, Capt. Phil Cotton, engineer Jose McNally, and FF/PM Paul Kozik. Pictured below, Capt. Terry Collis (far right, in turnouts) and his crew assist a pilot who had to make an emergency landing on U.S. Highway 78 just before U.S. Interstate 5. The pilot had an engine failure and landed safely on the westbound lanes but was spun-out by a minivan after landing.

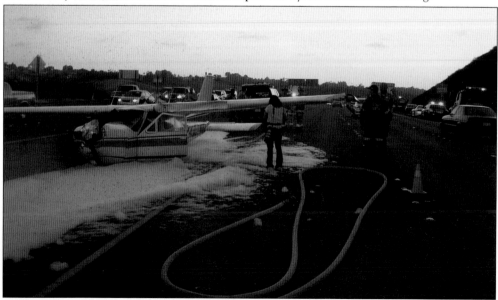

One of the most constant Oceanside Firefighter's Association charity events over the years has been the surf contest. Firefighters from throughout Southern California come to Oceanside for a day of surfing and relaxing, and proceeds from the event go to Casa De Amparo, a local home for abused children. Pictured below, engineer Oscar Ayala towers over Capts. Tracy Hawk and Shawn Fernandes.

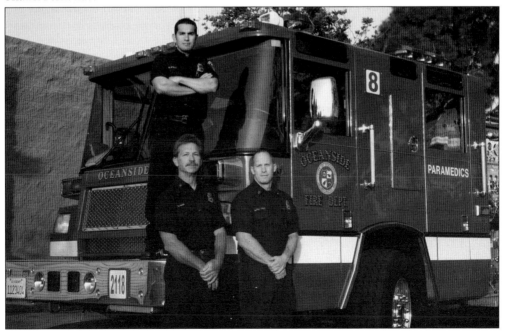

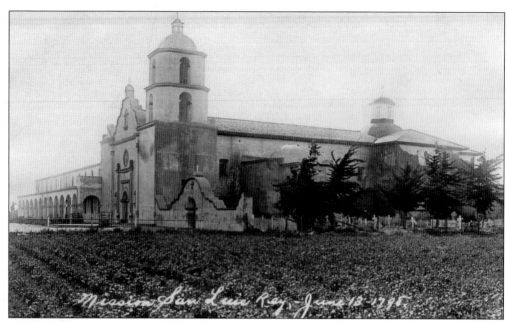

In 1971, the California State Resolution dedicating fire station No. 1 to Walter Johnson read that he "was a key figure in every important event in Oceanside." Looking back at the history of the fire department, the same could be said for the OFD in general. In 1798, Spanish missionaries built the legendary San Luis Rey Mission. The architect for station No. 7, Jeff Katz, did an impressive job of creating one of the country's most modern firehouses while capturing the proud history of the city of Oceanside. For generations to come, it will stand as a symbol of the pride and respect that Oceanside firefighters have of the city they serve. (Above, Oceanside Historical Society.)

Oceanside Fire Department's fire chiefs include W. H Fultz (1893), John Shuyler (1897), F. B. Shuyler (1900), L. W Stump (1906), Ernest White (1924), Walter Johnson (1929), John Billings (1959), Richard Trotter (1963), Jack Rosenquist (1973), Tom Moore (1983), James Rankin (1984), Jack Francis (1987), James Rankin (1988), Dale Geldert (1992), Robert Osby (2002), Rob Dunham (2005), Jeff Bowman (2006), Terry Garrison (2007), and Darryl Hebert (2009).

www.arcadiapublishing.com

Discover books about the town where you grew up, the cities where your friends and families live, the town where your parents met, or even that retirement spot you've been dreaming about. Our Web site provides history lovers with exclusive deals, advanced notification about new titles, e-mail alerts of author events, and much more.

Arcadia Publishing, the leading local history publisher in the United States, is committed to making history accessible and meaningful through publishing books that celebrate and preserve the heritage of America's people and places. Consistent with our mission to preserve history on a local level, this book was printed in South Carolina on American-made paper and manufactured entirely in the United States.

This book carries the accredited Forest Stewardship Council (FSC) label and is printed on 100 percent FSC-certified paper. Products carrying the FSC label are independently certified to assure consumers that they come from forests that are managed to meet the social, economic, and ecological needs of present and future generations.

Mixed Sources
Product group from well-managed forests and other controlled sources

Cert no. SW-COC-001530
www.fsc.org
© 1996 Forest Stewardship Council

Find Your Place in History.